Jesus / Now

Jesus / Now

by
Leslie F. Brandt

with art by
Corita Kent

Publishing House
St. Louis

Other books by Leslie F. Brandt
 EPISTLES/NOW
 GOD IS HERE—LET'S CELEBRATE!
 GOOD LORD, WHERE ARE YOU?
 GREAT GOD, HERE I AM
 LIVING THROUGH LOVING
 PRAISE THE LORD!
 PSALMS/NOW
 WHY DID THIS HAPPEN TO ME?

Concordia Publishing House, St. Louis, Missouri
Copyright © 1978 Concordia Publishing House
Manufactured in the United States of America

Library of Congress Cataloging in Publication Data

Brandt, Leslie F.
 Jesus/now

 1. Bible. N.T. Gospels—Paraphrases, English.
2. Jesus Christ—Art. I. Title.
BS2557.B73 226'.09505 77-28652
ISBN 0-570-03268-7

4 5 6 7 8 9 10 11 12 PP 90 89 88 87 86 85

Contents

Preface

It is presumptuous enough to speak or pray as the psalmist might in the 20th century (*Psalms/Now*), or to write as the apostles might were they living today (*Epistles/Now*); but to attempt to interpret Jesus' teachings in the same manner may offend rather than enlighten some of my readers.

Nevertheless, the purpose of most sermons or written meditations is to make those ancient thoughts and words of the Scriptures living and relevant to those who are living in this century. This is what I have attempted to do with the words that Jesus spoke as recorded in the four gospels.

Thus the words of this volume are an attempt to relate to you what I hear Jesus saying today. It is entirely possible that you may hear Him saying something more—or less—than what I have tried to relate. In the event that he is speaking to you some of the same words I hear Him saying, I sincerely hope that the reading of parts or all of this volume will reaffirm or provoke or challenge or enlighten or comfort in accordance with your specific needs.

Leslie F. Brandt

For Those Who Are Seeking God

He Is Seeking for You

The kingdom of God has come near to you.—Luke 10:9b

You say you are seeking for God.
It is strange that you have not found Him.
He has been near to you—He is near to you;
 indeed, He has been seeking for you.
Perhaps you have been looking for Him in the wrong places;
 you expect to find Him at the end of some
 religious pilgrimage,
 in some holy temple, in a picture, a book,
 a vision or a dream.

Maybe you are not seeking for God at all
 but for a happy feeling, an ecstatic experience,
 something that will numb you to the sufferings
 and atrocities of this cruel world.
You might even settle for a bit of magic,
 a smattering of security, a miracle or two.

Unless the spirit of darkness succeeds
 in stifling your inner spirit with the ephemeral
 delights of this passing world,
 you will continue to seek for God—
 or to yearn for Him—
 even until He finds you.
He is the fulfillment of your deepest needs.

You were made by Him and for Him;
 you will not find true joy or peace
 unless you return to Him—
 unless you allow Him to find you.

Luke 11:10; 12:31

God Is Revealed

Truly, truly, I say to you, unless one is born anew, he cannot see the kingdom of God.—John 3:3

If you are truly seeking God,
 you can find Him through Jesus Christ—
 what He has done on your behalf.
He has come from God;
 His Spirit seeks to unite with your spirit,
 to reflect and effect the Father's forgiving love
 and to restore you to His order and orbit
 for your life.
It demands, however, a radical change in your life.
It is very much like being physically born again.
It resolves in embracing Christ and His teachings,
 in following Him in respect to His activities.

Acknowledge your fruitless striving,
 your selfish struggles to measure up
 to God's standards and purposes for your life,

and accept the righteousness He has made possible
through Jesus Christ.
You cannot do for yourself what God has already
done for you.
You can, by His enabling Spirit,
turn away from sin, rejoice in His forgiveness,
and dedicate your life to living by His precepts
and objectives as Jesus has made them known to you.

God loves you.
He has revealed that love in what He has done
for you through Jesus Christ.
You can never destroy God's love,
but you can resist it in carelessly ignoring His
redeeming love or in your foolish efforts
to be deserving of His love.
God desires that no one should perish.
He, through Christ, endured much suffering on your behalf
that you might be reconciled to Him.
You who were born in sin may, by His Spirit,
be born anew, freed from sin's damning guilt,
free to live forever, with others who follow Christ,
as God's beloved children.

John 3:1-15

Where You Can Find Him

Jesus said to him, "I am the Way, and the Truth, and the Life; no one comes to the Father, but by Me. If you had known Me, you would have known My Father also; henceforth you know Him and have seen Him.
John 14:6-7

The Spirit of God does not confine Himself
 to the church pulpit or the sacred Scriptures.
Whereas God's infinite love is surely revealed
 in these places,
 you may not have been ready for such revelations.
Perhaps you have felt His presence during a meeting
 with a stranger; while reading a book,
 listening to a chorale, coversing with a friend.
On the other hand, you may not really hear His voice
 until you have reached the dead end
 of a long and twisted road.
You may experience a spent and wasted life,
 painful conflicts that you are unable to control,
 burdens you cannot carry, before,
 in a final, desperate reach for meaning,
 you will encounter His patient love
 or grasp His saving grace.
Then only, through the Christ of the Scriptures
 which you previously ignored,
 you may hear and respond to the blessed invitation
 to come to God and cast your life
 with all its burdens upon Him.

Yet there are multitudes who will never find
the God of love and mercy because they fail or refuse
to recognize His loving-kindness through Christ.
Jesus continues to be "the Way, the Truth, and the Life";
no one comes to the Father except through Him.
For those who do come,
there is rest from their fruitless labors,
forgiveness of their sins,
and the guarantee of everlasting life.
They become God's beloved children,
sons and daughters, with Christ,
of their gracious Father in heaven.

Thanks be to God;
your relationship to Him is not dependent
upon your intelligence or your profound insights.
It comes from God Himself.
It is appropriated by a simple, childlike faith,
by submitting to His love and yielding to His grace.

John 4:7-14; 14:5-7

In Response to Need

*Come to Me, all who labor and are heavy laden, and I will
give you rest.*—Matthew 11:28

Those, of course, who assume they are whole,
who apparently have no need for God,

are not likely to find Him—
 at least not while they are in that frame of mind.
Those who are ill reach out for healing.
Those who are hungry will scrounge about for food.
Those who are poor seek for material riches.
Thus those who are poor in spirit, who realize
 their lack, their emptiness, their sickness,
 the purposelessness and powerlessness of their lives,
 they are the ones to whom Jesus has come to witness.
They are the ones in whom Jesus can do the work of
 fulfilling, healing, forgiving, empowering,
 and to whom He can reveal the God of their creation,
 their loving heavenly Father.

The self-sufficient, self-important, self-contained
 inhabitants of this world are out of God's reach.
The Spirit of God must break up the shallow,
 hard-packed soil;
 this often involves painful,
 even devastating, experiences before the seed
 can be sown and ultimately bear fruit.

You may remember the story Jesus once told about
 the treasure buried in a field—
 and the surprised finder who sold all he had
 in order to purchase the field that he might
 obtain the treasure—
 or about how new wine bursts old wineskins.
This is what this new birth, this new life,
 this reconciliation to God is all about.
Coming to God demands a complete turnabout,
 a selling out, a total relinquishment
 of one's life and being to God and His purposes.
Darkness cannot exist in the midst of light;

nor can the darkness of man's vain attempts
and fruitless endeavors exist in the light
of God's required and freely given righteousness.
It is true:
Only those who come to God by way of Jesus Christ
will be made whole again.

Matthew 11:25-30; 13:18-23, 44-46

What It Means to Believe

*Truly, truly, I say to you, unless you eat the flesh of the Son
of Man and drink His blood, you have no life in you; he
who eats My flesh and drinks My blood has eternal life,
and I will raise him up at the last day.*—John 6:53-54

You who seek God must try to understand
what it really means to believe in God.
As food is eaten and thus received into the body
and thereafter supports the total life system
of the individual,
so the Spirit of God must be embraced, absorbed,
taken into your spirit to become the source
of your strength as well as the motivating purpose
for your lives and living.
Jesus has come from God.
Assuming your humanity and subjecting Himself
to the same forces that shape your lives,

He has identified with you
in order that He may relate to you.
He is the Light of God and the Love of God,
the communicator of His grace
to His creatures in this world.
You are to identify with Him, partake of Him,
receive Him as your Savior and Lord.
When you do this, you become restored children of God;
and you become, with Christ, lights that force back
the darkness that threatens to shroud this planet.
When you do this, you truly begin to live—
for yourselves, for others, and forever.

Your profession of faith is important.
If it is sincere,
it is a beginning—but only a beginning.
A genuine profession will be followed by obedience
to Christ's will and purpose for your lives.
You become one with Him as He is already one with God.
You become with Him the children and servants
of His Father.
There are scores of people who assume they are working
for Christ and yet have not become identified with Him.
There are others who seek to use Him and His name
to push their own projects
or further their self-centered objectives.
They even call on Him for help when life becomes
too much for them to handle.
Yet they have not allowed Him to become the source
and power of their lives.
They have not really learned what it means
to believe in God.

John 6:53-58

The Faith of a Child

Truly, I say to you, unless you turn and become like children, you will never enter the kingdom of heaven.
Matthew 18:3

You who have heard Christ's teachings
 and followed His activities
 may have been offended, even repelled,
 by what He has said and done.
His sayings and actions have at times seemed absurd.
They sometimes appear to contradict human rationale—
 even some of the religious activities
 that you sincerely participate in.
Maybe you are too wise in the ways of the world
 to be in tune with the voice of the Spirit.
Perhaps this is the reason that children are
 such likely objects of divine love—
 and readily respond to God's love for them.
Their minds are not yet cluttered with regulations
 and religious ceremonies and intellectual pursuits,
 with human reason and logical analyses.
They have not yet assumed the necessity of earning
 or meriting the gifts that are placed in their hands.
They give love in response to love.

Is it to be wondered at, then, that Jesus enjoins you
 to become like children in order to find God?
The laws that govern your universe are important.
You have been intellectually equipped to utilize those

forces to benefit yourselves and humanity about you.
But they are not expected to take the place of God
in your lives.
They are superseded by Him who is sovereign
over those forces and who lovingly created
and implanted you within them.
The redemptive and reconciling power of God is received
through the mightier force of faith,
a power that is remarkably present
in the hearts of children.
It is this kind of faith that gladdens the heart
of the Father, that will unite you to Jesus Christ
and therefore to God, forever.

Matthew 18:1-4

When You Seek for Truth

I am the Bread of Life; he who comes to Me shall not hunger, and he who believes in Me shall never thirst . . . All that the Father gives Me will come to Me; and him who comes to Me I will not cast out.—John 6:35, 37

Are you really concerned about truth?
Will that insatiable longing within you
be satisfied with nothing less?
Then you are blest indeed.
God is preparing you for what He desires to give you.

You may be tempted to follow many shepherds,
 to knock on many doors,
 to listen to many voices and walk many paths,
 before you finally realize that what you have been
 seeking has been close beside you all the time.
It is that truth which has been revealed to you
 through the words and deeds of Jesus Christ.
He has not spoken about or for Himself;
 He has spoken on behalf of His Father, who sent Him.
He knew God because He came from Him.
He came to you that you might know the Father
 and relate to Him as His beloved son or daughter.

You have heard Jesus speak of Himself as
 the Bread of Life,
 the Living Water,
 the Way and the Door,
 the Shepherd of the sheep.
Hear His words, hear them carefully,
 for they are not His alone;
 they are the very words of God.
Look again at what He has done—
 for you and the human family about you.
How can you fail to see that He is the way to knowing
 and experiencing the saving love of God?
Take Him into yourself, identify with Him,
 partake of Him, follow Him.
Then, even amidst the doubts and temptations
 that beset you, God will have found you;
 and you will be well on your way to knowing
 and experiencing the way of life and truth.
Then you will be Jesus' disciples
 and the sons and daughters of the Father forever.
John 6:35-51; 7:37-39

Living or Dying?

So if the Son makes you free, you will be free indeed.
 John 8:36

Many of God's creatures don't know what life
 is all about.
They laugh and dance, indulge and spend,
 and find some satisfaction in pursuing thrill,
 excitement, danger, popular acclaim,
 and material security.
They follow their selfish instincts
 or yield to their craven desires.
They convince themselves that this is living,
 when it is really the process of dying.
They are unsuspecting victims of bondage, enslaved
 by their own self-centered concepts and convictions.

Jesus has come to set men and women free from this bondage.
He does not rid people of their instincts
 or eradicate their natural inclinations,
 so impregnated with self-concern.
He can, infilled by the Spirit who enabled Him
 to successfully confront temptation,
 grant to those who seek it the power
 to subdue their selfish desires and passions,
 and He can bless them with the kind of joy
 that will make their lives whole and abundant.

Those who continue to seek for purpose and meaning
 along other corridors of this temporal existence
 may ultimately find the door to eternal joy
 and abundance closed shut.
They remain blind to the truth,
 deaf to the word of God's love,
 numb to the movings of His Spirit in and about them.
Their good works and fine intentions avail them nothing.
They have not sought for God.
They have never found Him.

John 8:34-38

Come to God's Party

*And at the time for the banquet he sent his servant to say
to those who had been invited, "Come; for all is now
ready."*—Luke 14:17

Only those who accept the invitation
 will enjoy the party.
There is no limit to the number
 who are invited to this ongoing event—
 this experience of eternal joy that God has prepared.
Nor are there qualifications or standards
 that must be measured up to in order to attend.
But there is no room for procrastinators.

Most of the invited are apparently involved
 in parties of their own.
Or they are so busy about mundane matters
 that they have no time to embrace
 and celebrate the love and joy of God.
They make all sorts of excuses:
 a family to rear, a paycheck to earn,
 a prize to win, a goal to attain, a life to live—
 even some religious exercise to perform.
God's party can wait until some more convenient time—
 or after the other parties prove dull and unsatisfying.

God is indeed patient, but the opportunities
 to come to Him are not unlimited.
And there are others who will respond to His invitation;
 these are the ones He will seek out
 and receive to Himself.
They shall feast at God's banquet table forever.

There is, however, one requirement that must be met.
Not only must those invited truly desire to come,
 they must come as they are—with no strings attached.
It is not a costume ball.
It is a celebration, a recognition of who they are
 and what they have become by the grace of God.
Those who come under the disguise of their
 personal merits will find little joy at God's party.
They will have little to celebrate for they are incapable
 of receiving what the Host so graciously offers.
And if they have not met Jesus Christ,
 and accepted God's love through Him,
 they will not feel welcome at the Father's party.

Matthew 22:1-13

Stop Running

*And he arose and came to his father. But while he was yet
at a distance, his father saw him and had compassion, and
ran and embraced him and kissed him.—Luke 15:20*

You are very important to God.
While His children are numbered in the millions,
 none of them is of more value than you.
This is the greatness of His infinite love and grace.
This is the reason He continues to seek for you—
 to reach for you—that He may draw you
 into the circle of His redeeming love.

You may keep running if you so choose.
He will not force you to submit to His purposes
 for your life.
But should you tire of running from Him,
 you will find that He is not far away,
 that He is waiting to receive you to Himself.

Jesus has come from the Father to show you
 the way back to life and truth.
Listen to His words—follow after Him;
 then you will know God's blessed will for your life.

Luke 15:11-24

For Those Who Are Religious

The Need to Be Religious

Think not that I have come to abolish the law and the prophets; I have come not to abolish them but to fulfill them.—Matthew 5:17

In your need to be religious,
 to relate to some indefinable security beyond your world,
 to discover some meaning for life and purpose for living,
 some of you resurrect the ancient Law,
 or a set of rules and regulations,
 and make that the guiding star of your lives.
And then you manipulate it into serving yourselves
 and your interests,
 assuming that it equally and adequately serves
 the needs and interests of others as well.
The Law that God gave to His chosen people
 was important for them and their times.
It serves well today in roughly defining priorities
 in people's lives and in giving some direction
 or order in human relationships.
It has been the basis for innumerable religions
 that people subscribe to and cling to
 in their search for God.

It does not, however,
 effect a right relationship with God.
It does not reveal God's saving love
 nor the manner in which men and women
 are to respond to His love.

It becomes, in the lives of many people,
> a substitute for God and His will and order
> for their lives.
It often destroys rather than redeems,
> separates rather than unites,
> divides rather than reconciles people to God.
It is not the Law by itself that does this,
> but mankind's vain attempts to live by the Law
> and to assume that this effort keeps them
> in harmony with God.

Jesus has come to do for you what the Law cannot do,
> to reveal the love of His Father,
> to redeem you from the bondage of rules and regulations,
> and to reconcile you to God.
You can know and experience God's love,
> and learn how to love in response to God's love,
> only through Jesus Christ.

Matthew 5:17-48

The Obstacles to True Faith

Not every one who says to Me, "Lord, Lord," shall enter the kingdom of heaven, but he who does the will of My Father who is in heaven.—Matthew 7:21

God did reveal something of Himself
> and His love for the children of Israel

through the giving of the Law.
His chosen people through whom He was ultimately
 to reveal Himself through Christ were fenced about,
 corralled by His statutes.
This Law became their religion—
 and those who made honest attempts to live by that Law
 considered themselves the objects
 of God's goodness and loving-kindness.
Those who ignored or disobeyed the Law
 became the objects of prophetic denunciations
 and the threat of damnation.

From that time until this,
 laws and rules and regulations have become a religion
 for masses of this world's inhabitants.
And now, in spite of God's revealed love through Christ,
 people continually attempt to pacify
 a holy and all-righteous God by way of
 self-imposed standards that allegedly please Him
 or religious ceremonies which pretend to honor Him.
They often become, these laws and standards,
 the very thing that stands between people and their God.
Laws continue to be necessary in society
 to guarantee some kind of order,
 to enforce justice, to keep sin-ridden human beings
 from destroying each other.
They are, however,
 incapable of relating men and women to God.
Whereas the law of God does serve God and humankind
 in terms of revealing the brokenness,
 the emptiness, the insufficiency of the human spirit—
 and thereby may prepare people
 for God's ultimate revelation through Jesus Christ—
 it does not unite God's creatures to Himself.

This is what Christ has come to do—
 to reconcile you to the God of your creation,
 to proclaim and demonstrate His mercy and love,
 to show you the way and grant you the power
 to embrace His forgiving love.

Mark 7:1-8, 14-23

The Standards of God

And He said to them, "You shall love the Lord your God with all your heart, and with all your soul, and with all your mind. This is the great and first commandment. And a second is like it, you shall love your neighbor as yourself."—Matthew 22:37-39

The law of God, which the ancient commandments
 attempted to explain and clarify,
 is summed up in God's requirement to love Him
 with your total being and to love your fellow persons—
 your brothers and sisters in the human family—
 in the manner that you accept and love yourselves.
This is the standard of righteousness that God
 requires of His creatures, and this is the standard
 that Jesus has measured up to and fulfilled.
No one can add to or subtract from God's requirement.
If people could accept and live by this requirement,
 they would truly be the children of God.

34

But they cannot—no matter how many rules and regulations
or laws and statutes they accumulate in their sincere
but futile attempts to please the heart of God.
And all the pious activities and relgious experiences
in the world cannot cover up this incapability.

It is because men and women are born into the world
with a nature that has been permeated and tainted
with self-will and sin that they need a new birth—
new hearts—lives set free from sin's enslavement
and focused upon God's gracious will and design
for His creatures.

Jesus has come to make that possible—
to witness as to what His Father requires,
to demonstrate what He desires,
and to release you from sin's bondage
that you may aspire to and grow toward
and abide within God's righteous will for your lives.
Jesus can restore you to a right relationship with God.
He has accomplished what is necessary
to effect that relationship.
You need only, by faith,
to accept what He has done on your behalf,
to identify with Him and His purposes for your lives,
and to follow Him as His disciples.
Then you, also, will learn how to love God
with your total beings, and your fellow persons
as you love yourselves.

Matthew 22:34-40

Trying to Be Religious

*Beware of practicing your piety before men in order to be
seen by them; for then you will have no reward from your
Father who is in heaven.*—Matthew 6:1

You have tried to be religious.
You say that you believe in God
 and you demonstrate that
 by your support of religious institutions.
You make regular visits to your particular shrine.
You pray at appropriate times
 and dutifully repeat your confessions.
But God's standards require you
 to make Him the focal point of your life,
 to love Him with all your heart and mind and being.
You insist that you respect your fellow persons
 and that you do nothing to hurt them.
God requires you to love your neighbors—
 to regard them as your very sisters and brothers—
 to share with them your gifts and even your very life.

The leaders of God's people during Christ's
 earthly ministry also tried to be religious;
 and they, indeed, assumed they were religious.
Jesus tried to show them that it was their very religion—
 their assumption that their adherence
 to rituals and ceremonies
 and prefabricated rules and laws
 would make God well-disposed towards them—
 that stood between them and their Creator.

They refused to accept Christ as God-revealed
 and indicted and crucified Him as a traitor
 because He proclaimed a loving God
 who required and provided a righteousness
 that was far superior to the burdensome religion
 they embraced and imposed upon the people.

Your very religion may stand between you and God—
 if, that is, it is not a loving and obedient response
 to God's forgiving and saving love
 as revealed through Jesus Christ.

Matthew 6:1-8

Religion You Wear Like a Coat

*What comes out of a man is what defiles a man. For from
within, out of the heart of men, come evil thoughts,
fornication, theft, murder, adultery, coveting, wickedness,
deceit, licentiousness, envy, slander, pride, foolishness.*
 Mark 7:20-22

Lip-worship is as common in your day as it was
 when Jesus visited this world.
People not only respect the traditions of the past—
 as they ought to do—
 but they inordinately honor them
 and desperately clutch at them
 like a drowning man latching on to floating debris.

They wear their religion—put on their religion—
　　the way a person might put on a coat.

As the prophets persistently enunciated,
　　this is abominable to God.
Hymn-singing, the making of prayers,
　　the confessing of creeds,
　　the symbols and rituals and religious exercises
　　that are an important part of your churches,
　　are valid and desirable—
　　and they are pleasing to God.
But He looks deeper into the heart of man and woman,
　　into his or her real desires and motivations,
　　into the honest beliefs and intents
　　of His human creatures.
He looks for faith.

The Spirit of God breaks through the visible
　　and the apparent, the words people say,
　　the motions they go through,
　　and the rituals they perform;
　　He sees and knows what is in the hearts
　　of His children.
If hatred is there,
　　recognized but unconfessed sin there,
　　disobedience or faithlessness there,
　　the Spirit of God knows
　　and the heart of God is displeased.
The hymns of praise, the verbal confessions and prayers,
　　and the religious ceremonies enacted do nothing
　　for those people who wear their religion like a coat.

People may impress their naive and undiscerning friends
　　with their religious activity,

but God looks into the hearts of His creatures—
and He knows what goes on there.
It is not what a person wears
that makes that person acceptable to God;
it is what he or she truly believes—
what he or she is really committed to—
that determines the source and object
and quality of faith.

Mark 7:6-23

Playing Games with God

Then said Jesus to His disciples, "The scribes and the Pharisees sit on Moses' seat; so practice and observe whatever they tell you, but not what they do; for they preach, but do not practice."—Matthew 23:1-3

One needs to be wary of those people
who make strenuous efforts to appear religious.
They may be playing games with God—and man.
If their words and deeds are the outpouring
and overflowing of love for God and humankind,
and if they are accompanied by humility
and a genuine concern for humanity,
by the willingness to be servants to
rather than masters over their fellow beings,
then the Spirit of God is working within
and through them.

If their proclamations are ostentatious and self-serving,
 if they are self-centered, bigoted,
 prejudicial, success-oriented,
 if they are more concerned about their own image
 and are utilizing their God-given gifts for self-glory,
 they may be using God or the God-language
 to push their own projects
 and accomplish their own objectives.

Whereas your discernment in respect to these people
 may be faulty—and this is dangerous—
 you need to be aware lest you be sucked
 into their religious game-playing and become
 less than authentic in your search for truth.

The person who is deeply committed to God and His purposes,
 who accepts his or her own humanity,
 its fallibility and failures,
 who responds to God's forgiving love
 and indwelling Spirit,
 and recognizes the injunction and call
 to be a loving servant,
 who emulates Jesus Christ
 in His loving and sacrificial servanthood,
 that person is an authentic Christian
 who truly is assigned to building God's kingdom
 in the world today.

Matthew 23:1-12

Label and Libel

Now you Pharisees cleanse the outside of the cup and of the dish, but inside you are full of extortion and wickedness.—Luke 11:39

A person's religious label may be honored
 by many in your society.
It makes no impression whatsoever
 upon the heavenly Father.
It is often a cover-up for selfish
 and sometimes illegal activities.
And, as with the Pharisees of Jesus' day,
 it blinds its victims to life and truth
 and makes them the agents of darkness
 rather than the servants of light.
They unwittingly, unknowingly,
 become the very enemies of God,
 roadblocks to the advancement of His kingdom.

There are those who use the name of Christ
 and sing His praises at their weekly worship services
 and dedicate the other six days of the week
 to their own self-centered pursuits.
They verbally confess Christ as the Savior of the world
 but try to use Him as their own private protector
 and dispenser of good things.
They acknowledge His love for themselves
 but show little concern for anyone
 beyond their own family or circle of friends.

They assume they are meant to travel first-class—
 with God's blessing—
 while the rest of the world
 is expected to be content with steerage.
They actually believe that their comfort and well-being
 are the consequences of their religious faith.
They may not admit it,
 but they act as if they are of more value to God,
 more favored by Him,
 than are those masses who are still living in darkness
 and struggling desperately for the very necessities
 of existence.
They pay for their right to believe this with large
 contributions toward the building of beautiful shrines
 where they may occasionally be inspired and solaced
 in the religion of their choice.

What is so very sad is that some of these people
 sincerely believe that they are the children of God.
They may be no closer to God than those very religious
 but blindly ignorant and faithless Pharisees of Christ's day.

Luke 11:37-52

Blind Leading the Blind

You blind Pharisee! First cleanse inside of the cup and of
the plate, that the outside also may be clean.

Matthew 23:26

Whereas most religious leaders today are faithful and true,
 some may be no closer to the kingdom of God
 than were the leaders of the people
 Jesus ministered to when He sojourned on this planet.
Their behavior may differ,
 but the net result is often the same—
 people are blindly guided down paths
 that do not lead to God.
The religious leaders of Christ's day were dictatorial
 and oppressive.
There are a few leaders today who are out to entertain,
 to conduct ego-fulfilling popularity contests,
 or they concentrate primarily on building buildings,
 raising budgets, and recruiting membership.
They assume that success is measured by statistics.
They may be more concerned about their own names
 and reputations than they are about God and His purposes.
Their ministry tends to be a personal ego-trip,
 and they are more into self-gratification and glory
 than they are for self-denial and cross-bearing.
They shun provocative issues,
 regard social needs as nonspiritual
 and perpetuate an impractical pietism

Conte

that keeps the emotions high
but fails to meet the real needs of God's children.
Or, on the other hand, they may be more concerned
about straightening out this world
than they are about the spiritual vacuum
in the hearts of their constituents.
The point is that some of them are not proclaiming
the Gospel as Jesus came to proclaim and demonstrate it.
They subtract from it or add to it,
and the result is a pathetic mishmash that becomes
a stumbling-block for those who are seeking God.

Be aware of the leaders you follow.
If they do not introduce you to a forgiving God
as revealed through Jesus Christ—
and to discipleship and servanthood as exemplified by Him—
they may be leading you astray.

Matthew 23:13-28

The Law Fulfilled

Every one who comes to Me and hears My words and does them, I will show you what he is like: he is like a man building a house, who dug deep, and laid the foundation upon rock; and when a flood arose, the stream broke against that house, and could not shake it, because it had been well built.—Luke 6:47-48

The law of God still stands.
It is summed up in the requirement to "love your God
 with all your heart, and with all your soul,
 and with all your mind, and with all your strength,"
 and "you shall love your neighbor as yourself."
Not capable of measuring up to this high standard,
 religious people often interpret it
 in terms of what they don't do—
 they don't worship other gods
 and they don't kill or steal or commit adultery
 or bear false witness.

Jesus did not come to eradicate that law.
He came to fulfill it, to exemplify it,
 to translate it into terms of loving relationships
 with God and within the human family.
It involved a cross for Him;
 it involves a cross for those who follow Him.
This is something that many religions cannot comprehend
 and many religious people will never accept.
Some of them will consent to the necessity of Christ's

sacrifice as a guarantee for their eternal welfare;
they are not as likely to take seriously His injunction
to embrace the cross of self-denial and sacrifice
on behalf of their sisters and brothers in the human family.
They simply have not understood or accepted the meaning
and purpose of God's kingdom as revealed through Christ.
It is possible that they may never be a part of that kingdom.

Not all who are religious will enter the kingdom of heaven,
but only those who do the will of God—
who do what Jesus commanded them to do,
for His words and His deeds are God's will revealed.
If a person's faith in God does not result in obedience
to His will as proclaimed and demonstrated
through Jesus Christ, it is not the true religion.

Matthew 7:21-23; 22:34-40

Religious or Christian?

*If I then, your Lord and Teacher, have washed your feet,
you also ought to wash one another's feet. For I have
given you an example, that you also should do as I have
done to you.—John 13:14-15*

Of course you are religious.
You are respectable and responsible citizens.
You love your church and conscientiously measure up
 to its membership standards.

You care about those close to you
 and even show some concern for your neighbors.
Did not the Pharisees in Christ's day do the same?

God demands far more from you.
He insists on the kind of faith
 that begins with confession and proceeds to cross-bearing.
Not only are you to claim His loving forgiveness
 through Jesus Christ; you are to be like Him.
You are, as Christ has done,
 to accept your fellow beings where they are
 in order to patiently and lovingly lead them
 to where God wants them to be.
You are to stoop to the feet-washing level
 of your neighbor's need in order to lift him or her
 to the heights of God's loving acceptance.
It means your involvement with the excruciating sufferings,
 the pains and problems, conflicts and consternations,
 failures and defeats of your fellow beings,
 that you bear one another's burdens
 and share one another's sorrows.
It means that you put your lives on the line in loving
 and sacrificial action to bring justice and dignity
 and opportunity and validity to every human being
 within your reach or circle of influence.
It begins with the cross,
 the cross Jesus bore on your behalf;
 it resolves in your self-denial and cross-bearing
 on behalf of others.

Of course you are religious;
 but do you really want to be followers of Jesus Christ?

John 13:12-17

For Those Who Live for the Things of This World

The Tyranny of Things

Therefore do not be anxious, saying, "What shall we eat?"
or "What shall we drink?" or "What shall we wear?" For
the Gentiles seek all these things; and your heavenly
Father knows that you need them all.—Matthew 6:31-32

Some of those who are rich in the things of this world
 assume they have already found the kingdom of God.
Their lives are so glutted with the goodies and gadgets
 of this temporal existence that there simply is no room
 for God as Christ has revealed Him.
They have seen and they have conquered.
They not only have everything they want,
 but they have the power that their riches give them—
 power to move people about them,
 to induce or force people to serve them.
They have inundated their every physical sense and faculty
 with the sounds and sights, the odors and tastes,
 the thrills and ecstasies, that this world offers.
And, at least until health fails and death threatens,
 they have little concern for their spiritual needs
 and even less concern for the multitudes about them
 that they may be oppressing and depriving
 in their avaricious clutch upon the things of this world.

When their final hour upon this planet does draw near,
 and they begin to realize that they must part
 with their great accumulations of this world's bounties,

some of them may become aware
of how poverty-stricken they are.
Then it may be too late.
They who have never reached for God
 may have stifled forever their spiritual hungers,
 and they cannot sense or respond
 to God's reaching out for them.

God loves these people; He is no respecter of persons.
Nothing is impossible for Him,
 and no one is unreachable—except those who refuse
 to hear His Word and to receive the rich gifts He grants.

Matthew 6:24-34

Middle-Class Religion

*And Jesus said to his disciples, "Truly, I say to you, it will
be hard for a rich man to enter the kingdom of heaven."*
Matthew 19:23

There are some middle-class people within society
 who assume they *are* the kingdom of God.
They have been born into or become a part of
 a culture they believe is God's best for humankind
 and is God's gracious provision for those who honor Him.
They are comparably rich in view of this world's
 hungry masses that eke out their existence—meal by meal.

Religion is important to them—most of them—
 and has at least some place in their lives.
Rather than allowing God to use them, however,
 they seek to use God and religion
 to maintain or to raise their standard of living,
 to assure them of temporal and eternal security
 or grant them peace of mind.
Whereas they may not be as distant from God's kingdom
 as many of those who are very rich,
 they, also, are often hooked on the things
 of this world and find Jesus' injunctions to self-denial
 and cross-carrying upsetting and distasteful.
It is very difficult for them to give priority
 to God's purposes, to share the tangible securities
 they worked so hard for
 with those who have very little of this world's goods.
Their gospel of materialism
 takes precedence over Christ's Gospel of redeeming love
 and does not often extend to loving servanthood
 on behalf of their fellow persons.

It is not impossible for such people
 to enter the kingdom of God, but it will be very difficult.
While many of them may verbally and emotionally respond
 to God's saving grace, a much smaller number of them
 are willing to acknowledge the Father's ownership
 of the things they possess
 and their assignment to be God's stewards
 of the gifts He has placed in their hands.

Matthew 19:23-26

Religion Under Judgment

*If then you have not been faithful in the unrighteous
mammon, who will entrust to you the true riches?*
Luke 16:11

Many citizens of this society
　　may be credited for the advancement and progress
　　of what is called the Christian religion.
They have built the institutions and financed
　　the programs that have been responsible
　　for the spread of the Gospel around the globe.
Yet even they do not escape the judgment of the Father.
Their vision has often been short-sighted,
　　their efforts short-circuited,
　　by their adoption of Christ's teachings and promises
　　and their utilization of His gifts
　　for their own personal benefit even at the expense
　　of others with whom they were expected
　　to share those teachings and gifts.
They sing God's praises—many of them—
　　but they have not committed themselves to His purposes.
They have laid claim to their material security
　　and prosperity in Jesus' name and have allowed
　　their religious institutions to become private clubs
　　for their own comfort and consolation.
They have created snug harbors to protect themselves
　　from the storms of life that rage throughout the world.
They attempt to protect their way of life

irrespective of the suffering and injustice
which this may entail.

God has not given up on them.
They struggle with temptation and risk damnation
 because they focus upon temporal society
 and the acquisition of this world's material goods.
They are in constant danger of losing their souls.
There are, however, prophets in their midst—
 men and women who have learned
 to seek first God's kingdom
 and to use their gifts for His purposes—
 who are challenging the faithful
 to sacrificial service in Christ's name.
The church people of this generation should listen to them.
They cannot be the beloved children of God
 without being the servants and disciples of Jesus Christ.

Luke 16:10-15

Gifts That God Grants

But seek first His kingdom and His righteousness, and all these things shall be yours as well.—Matthew 6:33

You should not have to be enticed into the kingdom of God
 by a recital of the great rewards
 that await those who are faithful.

The love of the Father should be enough—His grace
 and forgiveness and His guarantee of life everlasting.
But the tantalizing tidbits,
 the shiny tinsel of this world,
 often succeed in blinding you to eternal values.
Many act as if this is all that life is—
 whatever they can acquire and indulge in
 within the few years that they reside upon this planet.
Has not Christ's resurrection proven to you
 that what you experience here,
 the blessings God grants you here,
 are but a foretaste of that eternal, unimaginable abundance
 that is promised by the heavenly Father?

There are joys and pleasures awaiting the children of God
 that these people who feast perpetually
 upon the pleasures of this world will never know.
The good and beautiful things of this world—
 books and music, arts and learning,
 sunsets and starlight, flowers and trees,
 oceans and mountains, the lesser creatures of God
 that fill the skies and the forests—
 they, also, are from the hand of the Father.
These things are to be received as gifts of God;
 they are to be enjoyed and appreciated
 and shared with others.
They must not, however, stand between you
 and God's will for your lives.
These things,
 along with the inventions of human minds and hands,
 are capable of smothering the inner spirit
 that reaches for the divine Spirit.

The kingdom of God, along with all of its riches,

awaits those who will come to Christ.
You may enter that kingdom and receive its riches
 by accepting and following Him as your Savior and Lord.

Matthew 6:31-34

Those Treasures That Will Not Fail

*Do not lay up for yourselves treasures on earth, where
moth and rust consume and where thieves break in and
steal, but lay up for yourselves treasures in heaven, where
neither moth nor rust consumes and where thieves do not
break in and steal.*—Matthew 6:19-20

You know what happens to the things of this world
 that comfort, entertain, and make you feel secure.
They wear out, rust out, and fail to please you
 when problems arise that they cannot solve.
Your banks fail; your precious trinkets are stolen;
 your natural resources are drying up;
 and the few things you manage to hold on to
 are incapable of ending your loneliness
 or filling your emptiness.
It is because your spirit was created for better things—
 for those joys and satisfactions that only God can grant.
They are the imperishable gifts that cannot wear out
 or be taken from you.

The birds that fly, the fish that swim,
 the animals that run and reproduce, hunt and kill,
 eat and sleep—
 they are content with their environment upon this earth
 because they were not given an inner spirit
 that reaches incessantly for union with the Creator-Father.
You were created in the image of God,
 to be His child, to find objective and meaning
 in loving and serving Him.
When your spirit finds total contentment with anything
 less than this, then it must be a dying spirit,
 a spirit asphyxiated by the accumulated
 and selfishly appropriated things of this world.

You cannot focus your life and energies upon the wealth
 of this world and still expect to know and ultimately
 experience the eternally abundant wealth of God's kingdom.
You are made to worship God—not the things He created,
 which are His temporal gifts to you.
It is when you worship and serve Him that you begin
 to accumulate eternal treasures that shall never
 be taken away from you.

Matthew 6:19-21

The Final Accounting

But God said to him, "Fool! This night your soul is required of you; and the things you have prepared, whose will they be?"—Luke 12:20

It seems generally accepted in this world that success,
 or life's worth,
 is to be measured by the size of a person's bank account
 or the amount of property that person owns.
This is not true in the kingdom Jesus represents—
 the kingdom He brought into this world
 and in which He invites you to participate.
The person who gathers solely for himself or herself
 in this world will never know the riches
 of the kingdom of God.
While possessions accumulate,
 the spirit remains poverty-stricken.
There simply is no room in a person's heart for God
 when it is cluttered up or enslaved
 by the tyrannical clutch of temporal things.

Whether you have to build more barns
 to store your surplus grain or hire more brokers
 to handle your investments,
 there is nothing that can forestall that day
 when all of your accumulated wealth
 will become like dry rot.
In that last hour,

when you would exchange all your worldly possessions
for an additional moment or two of life,
the final accounting will reveal a barren soul
that is not ready to meet its Creator,
an emptiness that nothing can fill,
a loneliness and a hunger that nothing will satiate.

Those who make their primary investments in this life
and the things that accompany it
will have nothing stored up for eternity—
only eternal poverty and darkness.
Those who receive Christ's gift of life
and invest their years upon this world in carrying out
the Father's purposes and in sharing their lives
and possessions with the human family about them
will discover that their final hour of this existence
is but a prelude to the abundant joys of life eternal.

Luke 12:16-21

Accumulators or Stewards?

*And I tell you, make friends for yourselves by means of
unrighteous mammon, so that when it fails they may
receive you into the eternal habitations.*—Luke 16:9

Christ, in one of His parables, relates
how some people who are not of His kingdom

invest their wealth in ways that serve to secure
 their existence upon this world.
They see to it that a portion of their material riches
 is used for the welfare of others.
They are wiser than many of those who claim to follow Jesus.
Christ does not condone some of their motives—
 which may be selfish—
 but there are times when their actions are more humane
 than the actions of many who confess His name.
Some of these people even discover
 that serving their fellow beings brings more satisfaction
 than accumulating possessions for themselves.

One does not enter God's kingdom by generously
 sharing his or her gifts with others—
 though a person may thereby benefit
 by the love and devotion of those whom he or she serves.
No one can come to the Father except through Christ.
However, all who come unto Him and become a part
 of His kingdom will accept their calling as stewards
 of God's great gifts and utilize them to bring light
 and joy into the lives of God's creatures about them.
They will find their greatest joy in serving others,
 because in serving them they are truly serving God.

What you have acquired and accumulated is not yours;
 all the good things that have come your way
 have come from the hand of the Father.
While they are given to enrich your life here upon earth,
 they are also granted for the purpose
 of enriching and blessing the lives of others.
When, however, you make God's gifts the objects
 of your loyalty and devotion,
 they take His place in your life

and become a curse rather than a blessing
and may render you ineligible for that life and kingdom
which He has prepared for you.
In that event, you are,
in the midst of your grand accumulations,
truly and eternally poverty-stricken.

Luke 16:1-9

For Those Who Are the Children of God

You Are His Children Now

Pray then like this: Our Father who art in heaven, hallowed be Thy name—Matthew 6:9

You, dear friends, are the children of God.
There is no language or human medium
 that can communicate the beauty and significance
 of that blessed relationship.
It is altogether beyond the comprehension
 of earthbound creatures.
Yet it is this that God makes possible
 for you through Jesus Christ.

It means that you need no priest to stand
 between you and God.
Nor do you need sacrificial altars
 upon which to offer your gifts to Him
 or stately temples in which to worship Him.
As a little child boldly approaches his father
 in love and need, so God is your Father,
 and you may confidently come to Him,
 worshipfully, penitentially, joyfully,
 daring to air your doubts, your fears,
 your problems and needs,
 knowing that He hears,
 that He rejoices in the faith of His children,
 and that He responds to their urgent requests.
You must, however, be open to God and your fellow beings.
As you claim His divine forgiveness,

so you are to relate in forgiving love
 to those about you.
As you relate your needs to Him,
 you must submit to His will for you.
As you seek His gifts, you are to share such gifts
 with your brothers and sisters.
As you look to Him for guidance, you are expected
 to walk in the paths He lays out for you.

When you worship or pray or sing His praises,
 be aware that this is done to relate to God—
 not to impress your peers.
Your Father knows your needs far better than you do;
 yet He desires that you communicate with Him,
 rely on Him, trust Him, abide in Him.
He rejoices in the love of His children;
 He urges you as His children to continually regard Him
 as your loving Father.

Matthew 5:2-12; 6:1-18

Children and Servants

Let your light so shine before men, that they may see your good works and give glory to your Father who is in heaven.—Matthew 5:16

Because you are the beloved children of God,
 you are the salt of the earth

and the light of the world.
You are His representatives,
 His vessels, His instruments,
 the servants of His kingdom on your planet.
Since Jesus absented Himself from your midst, you,
 infilled with His Spirit,
 are chosen and instructed to carry on His purposes
 among the peoples of the world.
You are to be like salt amidst the world's corruption,
 lights within its darkness.
It isn't enough to display your piety
 in religious exercises;
 you are called upon to demonstrate and manifest
 God's love for the unlovely and unloved beings
 that cross your path.
As you were introduced to your Father's love
 through Jesus Christ and through those who followed Him,
 so your fellow beings are to see
 something of the Father's love through you.
You may be the only means that God has
 of touching people around you with His love,
 of relating to them His Word,
 of enabling them to discover His saving grace.

It is not enough to pray for those people who do not
 know Christ as their Savior and God as their Father.
You must be willing to be the instruments
 through which God can reach
 the lost and wandering sinners around you.
Then you may pray in confidence
 for the strength and wisdom and divine grace
 to be salt and light, to love as He loves,
 to reach out to them as He reaches out to you.
You are, by God's salvation,

by His appointment and empowerment,
the salt and the light,
the life-giving channel or transmitter
of God's grace and power to the world.
The blessing of God the Father is upon those
who are faithful to their calling.

Matthew 5:13-16

God Cares About You

*Therefore I tell you, do not be anxious about your life,
what you shall eat or what you shall drink, not about your
body, what you shall put on.*—Matthew 6:25b

God the Father does care about you.
Thus you need not be overconcerned
about your physical needs.
The circumstances about you
or the calamities that befall your world
may at times press you into the dark corners
of depression and deprivation.
But you are the sons and daughters of a new kingdom.
You are fed and sustained by the Spirit
of your Father within you.
Your sufferings will not be greater
than He will enable you to endure.
Jesus knows, for He has gone before you,

and even when His human body was afflicted
with suffering and His soul oppressed,
His Father sent His invisible servants to impart to Him
the strength to continue in His eternal purposes
and the courage to carry out His objectives.
As there was for Christ, so there is for you,
 the joy of knowing that you are
 in the center of His blessed will
 and the objects of His everlasting love.

There are those hours in which human pain
 sharpens your focus upon those things
 that are really important for your lives.
There are those times when the poverty
 of your lives may be due to your failure
 to communicate your needs to your Father
 and to look to Him for the answers to your problems.
The Father of Jesus, your great God, never sleeps.
He is aware of your deepest desires.
He wants to fulfill them in the manner
 and to the extent that His purposes
 will be accomplished in and through you,
 so that your joy will be complete.

Matthew 6:25-34

Walk with God

Enter by the narrow gate; for the gate is wide and the way
is easy that leads to destruction, and those who enter by it
are many. For the gate is narrow and the way is hard that
leads to life, and those who find it are few.
Matthew 7:13-14

The path that you, the child of God, are to walk upon
　　will at times seem to be very narrow and difficult.
It will lead you into circumstances and relationships
　　that will test your mettle and refine your spirit.
There will be hot desert sands and soaring mountains,
　　hills and valleys, sun and clouds, thorns and flowers.
There will be vicious storms that frighten and obstruct,
　　and green oases that nourish and comfort.
It should not surprise you that many of your friends,
　　even some of your loved ones, will not accompany you.
They are more readily attracted by the glittering,
　　well-traveled freeways that beckon to adventure
　　and sensual thrills.
The path you traverse leads to God and His will
　　for your life.
The roads that are glutted with bumper-to-bumper traffic
　　lead only to the fast-fleeting pleasures
　　and satisfactions of this world.

Beware of those religious charlatans that herald
　　the walk of a Christian as an easy
　　and perpetually happy experience.

If you follow them, you will go astray.
Note well the issue of their lives, their values and motives,
 and the long-range consequences of their kind of leadership.
They may talk the talk that resembles
 some of the things Christ said and did in this world,
 but they do not walk the walk He exemplified.
It is those people who follow Jesus Christ,
 who hear His words and receive His life and do what He says,
 who will enter into abundant living and life everlasting.
Those who travel by some other route,
 regardless of their confessions and proclamations,
 will not weather the fierce storms of this life
 nor experiece the joy of abiding
 within the perfect will of God.

Walk upon Christ's paths and live by His words and deeds
 for your life—for they are, indeed,
 the will of God for you.

Matthew 7:13-14

Interpersonal Relationships

> *Judge not, that you be not judged. For with the judgment
> you pronounce you will be judged, and the measure you
> give will be the measure you get.*—Matthew 7:1-2

It is when you walk within God's will for your lives
 that you truly become, as members of God's family,
 the brothers and sisters of Jesus Christ.

Though the path is often difficult
 even as it is joyous, you need not be afraid
 because He has gone before you;
 and He, through His Spirit and the Spirit
 of His Father, walks with you.
Whereas you must be discerningly aware
 of the words and actions of those who seek to lead you
 on paths not of God's choosing,
 you must not become judgmental
 of those with whom you disagree or who may appear to take
 different routes than the course
 to which Christ has called you.
Judgment is in the hands of God alone.
Even God's invisible servants, His very angels,
 are not qualified to pass judgment upon His creatures.
If you assume that by your redemption
 and your reconciliation to God's family
 you are more important to God
 than His other creatures within the human family,
 regardless of their race, religion, or economic status,
 you will be tripped up by your own pride
 and become a stumbling block to others about you.

The temptations that will plague you are numberless.
You not only have Christ's sympathy, but His concern,
 and His promise that the Father will grant you
 the grace to withstand them.
Even when you foolishly yield
 to their power and persuasiveness,
 the forgiving grace of God is sufficient to restore you
 to His way and will for your lives once again.
There remain numerous anti-God taints and tendencies
 within your human natures.
Unless they are recognized and prayerfully placed

under the control of God's Spirit,
they are capable of leading you astray.
Nevertheless, be not afraid,
for the God who redeemed you will keep you forever
and will allow nothing to extract you
from His loving hands.

Matthew 7:1-14

Forgive and Be Forgiven

*So also My heavenly Father will do to every one of you, if
you do not forgive your brother from your heart.*
Matthew 18:35

The child of God is not exempt from the problems
and difficulties that afflict the human family.
There are mountains to climb and burdens to carry.
But never need he or she carry
the devastating burden of sin.
Christ's sacrifice was sufficient;
man's guilt was exonerated.
The forgiving grace of a loving God
has been appropriated.
Thus you have been forgiven forever
from all that you have renounced and put behind you.
You have been set free from sin's bondage and consequences
and can walk and leap and run as God's joyous children.

It is necessary, however,
 that the forgiven person become a forgiving person.
No matter how determined you are to walk with God,
 that blessed relationship cannot endure
 if you harbor or portray an unforgiving attitude
 toward a brother or sister.
Whereas such an attitude may be harmful
 for the person in question,
 its continued presence will be destructive for you,
 far more destructive than the wrongful acts
 committed by that person toward you.
Should you be tempted to consider that person
 as unworthy of your forgiveness, consider, as well,
 how undeserving you are of God's forgiveness
 of the enmity and rebelliousness
 you have often manifested toward Him.

The human family is marked with flaws and faults.
These are often visible in interpersonal relationships.
Like jealous siblings you find occasion
 to gnash at one another, to hurt or be hurt by one another.
Reflecting on the Father's love for each of you,
 those spiteful and ungracious incidents
 ought to become the opportunity
 to portray your Father's love for one another
 and to reunite around His blessed purposes once more.

Matthew 18:21-35

Serve God Where You Are

The harvest is plentiful, but the laborers are few; pray therefore the Lord of the harvest to send out laborers into His harvest.—Luke 10:2

The essential assignment of God's children is
 to love their fellow beings and to demonstrate
 that love and concern in their daily lives.
Whereas some of you may be compelled
 to leave your family and homeland
 in order to carry out God's global purposes,
 most of you will find your arena of service
 on your own street or in your own neighborhood.
The elderly lady next door,
 a sick child down your block,
 an oppressed minority community in your city,
 the victims of injustice, poverty, crime, and violence—
 these may well be the people you are to serve,
 the situations in which you are to witness.
It is not enough to proclaim God's presence;
 you are to *be* that presence.
He may not be able to touch those people except through you.

Do not measure your success
 by the visible response or results that may or may not
 be the consequence of your ministry.
You know well that Jesus' ministry
 among the people He physically related to in this world
 could hardly be statistically ascertained.

Our Father in heaven will keep accurate records.
His concern for you is not that you be successful,
 but that you be faithful.
Keep the lines of communication open between you and God.
Allow Him through His Spirit within you
 to accomplish His purposes through you.
As your feet run His errands
 and your hands perform His deeds of love
 among your fellow beings,
 may your tongue be ready to express
 the joy of God's life and Word that is in you.
This is your assignment
 as God's children and servants in your broken world.

Luke 10:1-9

You Pray—God Responds

*And I tell you, Ask, and it will be given you; seek, and you
will find; knock, and it will be opened to you. For every
one who asks receives, and he who seeks finds, and to him
who knocks it will be opened.*—Luke 11:9-10

If you, in spite of your inherent selfishness,
 are able and willing to give good things
 to your children,
 how can you doubt God's ability and willingness
 to impart to you the good things that you need
 to live joyful and fruitful lives?

Even strangers who owe you nothing will,
 if you are in some serious predicament,
 reach out to help you in your need.
How much more shall your heavenly Father,
 who loves you and watches over you,
 make available to you the necessities of life
 and the grace you need to walk and serve
 within His will for you!

There are times when He waits for you
 to demonstrate your dependence upon Him
 by expressing those needs in verbal prayer.
In such prayer you are to worship
 your loving, ever-reigning, and righteous God,
 to pledge your allegiance to Him,
 to acknowledge your sinfulness and receive His forgiveness,
 to dedicate yourselves to His eternal will,
 and then to trust that He hears and will respond
 in accordance with what is best for you.

Yet even before He hears your words, He knows your needs.
True prayer is really a day-by-day relationship
 of love and trust in the God who created you
 and reconciled you to Himself.
This relationship will, at times,
 be articulated in verbal praise.
It should always be demonstrated
 in quiet and joyous confidence—
 the confidence that you are loved
 and will be sustained and guided
 as you continue to follow and serve your God
 who reveals His love and will through the words and deeds
 of Jesus Christ.

Luke 11:5-13

You Are Important

For every one who exalts himself will be humbled, and he who humbles himself will be exalted.—Luke 14:11

You have been made the children of God,
 citizens of His kingdom, brothers and sisters,
 servants and disciples forever.
You are God's ministers to His human creatures around you.
It is this that truly gives you significance
 and validity—each one of you.
You need not, as do the cultists
 and nonreligious therapy groups about you,
 continue to struggle for self-realization and identity,
 for some sense of meaning and purpose for your lives.
You have all this—and much more.
Truly, you are the sons and daughters of God.

This must not, as it appears to with so many
 nonreligious movements, result in self-exaltation.
God is God; Jesus is God's Son, your Savior and Lord.
As with Christ, so with you—your allegiance is to,
 your dependence is upon, the Father in heaven.
You were created in His image,
 and even before your creation Christ was with God.
It is your redemption from sin and your reconciliation
 to your Creator and Lord that established forever
 your identity and personhood.

It is for this reason that you can afford
 to keep a low profile among your peers.
You do not have to be king-of-the-hill,
 to be more prestigious or recognized
 than your fellow beings.
Your validity is not determined by your fellow persons;
 it is established by God Himself.
While some of God's children
 do receive worldly acclaim and honor,
 others serve as well or better, as Jesus did,
 by suffering and dying on some ignominious cross.
Love deeply and walk humbly, whatever the cost,
 and in due time you will be exalted
 by your Father in heaven.

Luke 14:7-11

Humble Yourself—Glorify God

*Nevertheless do not rejoice in this, that the spirits are
subject to you; but rejoice that your names are written in
heaven.*—Luke 10:20

Self-exaltation must give way to God-glorification.
You may be allowed to witness the power of God's Spirit
 through you in your relationship to your fellow beings.
Someone may be healed because of your prayers.

Others were found and restored to Christ and to God
 because of your faithful witness.
Your request for God's intervention in some crisis
 was fulfilled.
You successfully resisted some persistent temptation
 and thereby confounded the forces of evil
 that plagued your soul.
It is amazing how many of God's children
 actually credit themselves for some of those things
 that happen to them or through them—
 and they assume that because of them
 they rightfully deserve the honor and respect of others.

Jesus wants you to be very cautious about this.
Give God the glory,
 for from Him comes the grace and power
 that touches people's lives through you.
He is the source of that eternal wisdom
 that enables you to discern and comprehend
 certain mysteries that even the most powerful
 and intelligent of this world's human creatures
 cannot perceive.
The great prophets of history were blind
 to the things you have seen
 and deaf to the things you have heard—
 yet even they had much to contribute
 to the understanding you have today.

Above all, you have Christ's witness in word and deed—
 the cross, the resurrection, the gift of the Holy Spirit.
Jesus was God-incarnate in your midst—God revealed.
You have found God only because He came to you
 through Jesus Christ.
So rejoice! Sing loud His praises!

And do this because He adopted you as His children—
and because He empowers and works through you
as His ministers.

Luke 10:17-22

You and Your Talents

I tell you, that to every one who has will more be given;
but from him who has not, even what he has will be taken
away.—Luke 19:26

As God's children and His ministers and servants
in a rebellious and disjointed world,
you are the recipients of God-imparted gifts
to be used toward the accomplishment
of His purposes in your world.
It is true that some of you appear to have more than others,
but every one of you
is of equal importance to God and has been entrusted
with talents to be used to glorify and serve Him.
The value or significance of these gifts
is not to be determined by the accolades of your peers,
but the manner in which they are accepted and utilized
for the glory of God.
The frightful thing is that even some of God's children
use them for self-service and self-gratification
and stagnate their lives by neglecting to invest them
in the needs of their fellow beings.

What is worse is that they thereby grieve
their loving God and become obstacles
to the advancement of His kingdom.

These talents are many and varied.
Not all of them are acknowledged or honored by one's peers.
The most profound ones, however,
may be the most invisible—
the gifts, for instance, of love, faith, patience,
understanding, sensitivity, courage, and the like.
They are all given because they are all needed
for the advancement of God's objectives.
You are, by the enlightenment and empowerment
of God's Spirit, to discern and acknowledge
and stir up the talents that have been committed to you.
Then you are to utilize them,
be they the abilities to make music or make money,
to preach or write or teach or paint pictures
or solve problems or whatever,
to serve the needs of those who may lack such abilities
and, ultimately, to extend God's kingdom
throughout your world.

Glorify God with your lives and talents!

Luke 19:11-27

God's Children Are Fruit Bearers

*By this My Father is glorified, that you bear much fruit,
and so prove to be My disciples.*—John 15:8

It is expected of God's children that their lives
 upon this world be fruitful.
God reveals His beauty and power and goodness
 in the creatures that serve you, the trees that shade,
 the flowers that delight, the fruits and vegetables
 and growing things that feed you.
His eternal love and grace for humankind
 is manifested by Christ, who came to you
 in and through the witness
 of your fellow beings about you.
He has made Himself dependent upon you,
 His redeemed sons and daughters,
 to extend His kingdom in your midst.
Thus it is imperative that you be fruit bearers,
 that you be the channels and instruments
 of God in your world.
This is the way Jesus revealed Himself to you—
 through those who by their lives and their witness
 communicated His teachings and activities to you.
Now you are to continue within God's great purposes
 and bear the fruit of His redeeming love
 to others who cross your path.

This does not require genius or some spectacular talents;
 nor does it require anxious or worrisome effort.

It is the Spirit of God who works out His purposes
 in and through you.
You need only to yield to and trust confidently
 in God and His will for your lives.
Fruit bearing is the result of a healthy relationship
 between the branch and the trunk of a fruit-bearing tree.
Service that is productive and contributive
 ought to be the normal and spontaneous consequence
 of a love-faith relationship to God through Jesus Christ.

You who are the children of God,
 be aware of your God-given grace and responsibility
 to be fruit bearers in your community and world—
 to consistently and perpetually allow God
 to work out His purposes in and through you.
It is thereby, even in the midst of suffering,
 that you will bear fruit
 and will find true joy and fulfillment.

John 15:1-11

For Those Who Doubt and Fear

He Has Not Forsaken You

*Fear not, therefore; you are of more value than many
sparrows. So every one who acknowledges Me before
men, I also will acknowledge before My Father who is in
heaven—Matthew 10:31-32*

Jesus knows the world is fearful and oppressive.
He has been immersed in its darkness,
 confronted by its enemies,
 and suffered under its persecutions.
The forces of evil that possess and use
 so many of the inhabitants of this planet
 are seeking mercilessly to disrupt your lives—
 even to destroy your souls.
They never rest, those evil powers,
 nor do the conflicts that they perpetrate upon you.

Neither does the Father rest;
 nor is He unaware of the problems that afflict you.
He is ever awake and fully congnizant
 of your fears and frustrations.
He knows and He loves every one of His creatures.

If He knows when a sparrow flutters to the ground
 with a broken wing, or when a young doe is attacked
 and devoured by a beast of the forest,
 surely He knows you, your trials and troubles;
 He is lovingly concerned about you.
Whereas He may not deliver you from your disjointed world

until that day when He takes you to Himself,
He will reach out to steady you, to comfort you,
even in the midst of your fears and doubts.

You will be afraid at times,
and doubts will cloud your minds,
for you are like lambs at the mercy of hungry beasts;
and you cannot always feel the presence of the Lord.
You may wonder, as Jesus did during those hours on the cross,
if God has forsaken you.
Jesus gives the assurance that God has not,
that He is never far off,
that He will, in His own good time,
deliver you from the darkness that confounds you
or the enemies that seek to do you harm.

Matthew 10:16-33

You Need Not Be Afraid

*When they deliver you up, do not be anxious how you are
to speak or what you are to say; for what you are to say will
be given to you in that hour.—Matthew 10:19*

Whereas it is to be expected that you fear those
who can maim or destroy your body,
even those who can force you to give up
your precious possessions,
Christ enjoins you not to be afraid.

You must remember that you belong to a new kingdom,
 an eternal kingdom, a kingdom not of this world.
Your physical being,
 the material gifts that come from God's hand,
 they are yours to enjoy,
 but they may not be yours to hold on to
 or to defend at all costs.
You can well afford to risk these things—
 even your very life—
 in the service of and for the kingdom of God.

God is, however, concerned about your physical being
 as well as your immortal soul.
Life, God's precious gift,
 is something to be cherished and lived to the fullest
 even as you invest it in God's purposes;
 however, the life you now hold to
 is but the prelude to life eternal.
God's life imparted to you through Christ is forever.

Jesus has challenged His followers
 to regard courageously and joyfully
 the possibility of losing their physical lives
 in the process of serving Him and their fellow beings.
Such a loss, in that event, resolves in immeasurable gain.
Christ challenges you to fear not what may happen
 to your physical being or those possessions you hold dear,
 but to reserve your fear for those things or those people
 who may be capable of obstructing your relationship to God
 and thereby cheating you out of life eternal.
In respect to your life and circumstances
 in this world, stop being afraid!
God truly cares about you.
Matthew 10:26-33; 11:25-30

God Knows Your Needs

And whatever you ask in prayer, you will receive, if you have faith.—Matthew 21:22

Jesus was one of you; He lived in your world.
He knows well the doubts that afflict you,
 the temptations that press upon you.
He knows, as well, the infinite power of true faith,
 the kind of faith that can move mountains
 of apparent impossibility and restore you to
 and keep you within the gracious will of God.
The Father does not dispense upon you all that you
 request of Him, because many of your whims and wishes
 are not necessary to your growth in His kingdom—
 and, indeed, may even hinder such growth.
But He knows your true needs; He hears your prayers.
He is ready to grant you everything that is required
 to enable you to be His loving and serving children.

You know how Jesus worked among the people in His day—
 responding to their needs with heaven's gracious power
 far beyond what they dared to ask for or expect.
The Holy Spirit continues to work among you—
 with the same love and power—
 healing, redeeming, setting free,
 and granting to you everything you need
 to give meaning and purpose to your lives.
God the Father expects you to recognize those needs
 and to submit them in trusting prayer to Him.

And having recognized and submitted those needs,
 you are to faithfully carry on, apart from tangible evidence,
 with the assurance that God has granted
 or will grant you His answer to your requests
 and His grace to accomplish the purposes
 of His kingdom in and through your lives.

If you will cease attempting to use God
 and allow Him to use you in accordance
 with His divine will, then you need not doubt;
 for you are living and praying in faith,
 and you are the recipients of God's uncountable blessings.

Matthew 21:16-25

Dark Nights and Difficult Days

*Fear not, little flock, for it is your Father's good pleasure to
give you the kingdom.*—Luke 12:32

There will be anxious moments in your life.
The world is insecure and unpredictable,
 and there are circumstances over which the Father
 does not have immediate control.
There is evil all about you which for a time
 will threaten and tempt and wound
 even the children of God.
You cannot avoid these things any more than Christ could
 when He was upon this world.

You will fear, even doubt at times;
 you will hurt and be unhappy.
There will be dark nights and difficult days.

There is one thing, however, of which you can be sure;
 it is the love of the heavenly Father.
This will never change even when the storms
 beat mercilessly upon your soul.
If your faith is in Christ and the Father,
 it will be shaken but it will never be destroyed.
When you know Jesus, you know the Father.
You know Him as a loving and just God
 who through Christ drew you to Himself.
' God is not about to let you go,
 to let some devil come between you and Him.
You are forever a child of God,
 and there is nothing in your world or your universe
 that can mar that relationship.

God will not always shield you from anxieties or wounds,
 but He will give you the strength and courage
 to face them.
He will, through the faith He has planted in your being,
 use even the fearful, distasteful, painful
 circumstances that afflict you to mature you,
 to hone your mind and mellow your spirit
 and prepare you for the gifts of His Spirit,
 that you may be an effective instrument
 in the accomplishment of His purposes in your world.

Luke 12:22-34

God Made Visible

Then He said to Thomas, "Put your finger here, and see
My hands; and put out your hand, and place it in My side;
do not be faithless, but believing. —John 20:27

It is not surprising that you long for tangible evidence
 of God's presence with you.
It is impossible for a human being
 born into and reared in this three-dimensional world
 to comprehend those vast, eternal dimensions of God
 that cannot be discerned by human faculties.
Even your God-inculcated faith needs the support
 of physical evidences, the assurance
 transmitted through God-given emotional feelings,
 that God is God and that Jesus is speaking
 the words and performing the works of His Father.

This is the reason that Jesus, God-incarnate,
 the Word made flesh, came to you
 by way of the manger and lived among you
 to be seen and heard and touched by you.
It is for this reason that He submitted to the hands
 of this world's unbelieving rulers
 and gave up His body to death on your behalf,
 only to be resurrected by the Father and to appear again
 to those who followed Him.
On one of the post-Resurrection appearances
 Jesus invited a skeptical disciple to relieve his doubts

by touching the wounds inflicted upon Him
 when He died on the cross.

Jesus has not left you without sufficient evidence
 of His human-divine presence and the salvation
 God offers through Him.
You have the word of reliable witnesses
 through the New Testament.
You are able to touch Christ—His body and His blood—
 through the bread and the wine of the Sacrament.
God has given His Spirit, who abides within you
 and bears witness to Christ and who energizes your faith
 and your claim upon His saving grace.
This is enough—
 this and the testimonies of the multitudes throughout
 history whose faith has conquered all doubts and fears
 and opened to them the gates to the eternal kingdom of God.
"Blessed are those who have not seen and yet believe."

John 20:24-29

For Those Who Sorrow and Suffer

Promise of Pain

*Let not your hearts be troubled; believe in God, believe
also in Me.*—John 14:1

Jesus knows about the pain and consternation
 that sometimes plague your lives.
He knows, as well, the enmity and opposition
 you may encounter as you seek to follow His teachings
 and promote His kingdom.
Remember that He warned you about this and challenges you
 to face courageously the loss of your goods,
 even the loss of your lives,
 and to daringly scorn such consequences
 in your loyalty to Him and His purposes.
He acknowledged long ago that sorrow and suffering
 would be the lot of those who follow Him.
While Christ could not promise peace and contentment
 as the world interprets these,
 He did promise and will fulfill the promise
 to flood your lives with the peace that God grants
 to those who yield to His saving grace.

Thus, even in the midst of troubled times
 and painful circumstances, you do not have to allow
 your hearts to be troubled.
You are secure in God irrespective of what happens
 to you or about you.
What Jesus permits in respect to the conflicts you encounter,

the tempests that batter your lives,
He grants you the grace to endure
and ultimately to overcome.

The years you spend upon this world are as nothing
when related to eternity and the everlasting love of God.
Jesus assured His disciples that the sufferings
they would contend with during His physical absence
from them would not even be remembered
in that day when God's kingdom is fully revealed
and the forces of evil and darkness are abolished forever.
In the meantime, He would always be with them—
invisibly but truly—and through His Spirit within them
would hold high the hope to which they had been called.
He will likewise guide you through the dark corridors
of this world's brokenness to that eternity
of joy and light.
Be cheerful—and faithful—even amidst your tribulations.
Time is short;
eternity and eternal peace and joy are forever.

John 14:1-14

When One Is Desolate

I will not leave you desolate; I will come to you.
John 14:18

Before Jesus took leave of His faithful followers
to do what He had often prophesied

but which they were unable to understand or accept—
bear the cruel cross on their behalf
and on behalf of all God's sin-ridden creatures—
He assured them that He would never leave them desolate.
Jesus knew well the sufferings they would endure
as they continued to follow His life and teachings.
His resurrection gave them the hope and courage
to risk all in the proclamation of His message.
It did not, however, lessen the pain and suffering
heaped upon them in their pursuance
of Christ's objectives.
Many of them died violently as the consequence
of their obedience to His injunctions.
Their obedience to Him,
resulting in suffering and death,
made possible the proclamation of God's love
and salvation to you.

Their testimony has been handed down to you—
that Jesus did not leave them desolate.
His invisible Spirit was with them
even within their sufferings,
succoring, sustaining, strengthening,
holding before them the joy and hope of life everlasting.
The promise He made to them is extended to you.
The Spirit that undergirded and uplifted them
is the same Spirit that abides within and about you.
Jesus cannot shield you from the suffering
that impregnates this world
and afflicts your individual lives,
but He will not leave you desolate.
He will not, if your faith is centered
in Him and His promises, allow it to destroy you.
He will even transform it into a means of refining

and sanctifying you within His purposes for your lives.
And He promises that there is an end to all pain—
 that suffering will eventually usher you
 into incomprehensible, eternal joy.

John 14:18-24

Life's "Little Whiles"

*So you have sorrow now, but I will see you again and your
hearts will rejoice, and no one will take your joy from
you.*—John 16:22

You exist within the "little while"
 of Christ's physical absence.
It began when Jesus left His disciples
 to return to His Father.
It will continue until He returns
 to gather the faithful into His kingdom.
He knows that this period may be for you,
 as it was for His first disciples,
 a time of sorrow, loneliness, and darkness.
There are times when you may feel,
 as they felt when He was taken from them
 and pressed upon the cross, that leaving everything behind
 in order to invest their lives in His cause was for nought.
There may be moments when you find yourselves
 doubting the very existence of a loving God.

You know what happened to those first disciples
 just two days after Jesus was placed in a tomb.
Their grief-stricken hearts were overcome with a new joy.
Their sorrow was transformed into vibrant gladness.
Their "little while" of darkness
 burst into the dawn of a new and glorious day.
That joy remained,
 along with God's invisible presence
 through His Spirit within them,
 to strengthen and encourage them
 through the severe sufferings and trials that lay ahead.

"So you have sorrow now," Jesus said to them,
 "but I will see you again, and your hearts will rejoice."
It is this that He says to you—even today.
Your sufferings shall not be for long;
 they will come to an end.
And they are no longer the "little while" of Jesus' absence,
 for He goes before you and He is with you
 through His Spirit that abides within you.
He is with you at all times—
 even amidst the sorrows and sufferings
 that will haunt you from time to time.
Do not shun them or fear these "little whiles" of pain.
Learn from Christ how to use them to develop your faith
 and sharpen your discernment of spiritual values.

John 16:16-22

Happiness or Joy?

These things I have spoken to you, that My joy may be in you, and that your joy may be full.—John 15:11

From the very beginning of His ministry
 as God's Son in your midst,
 Jesus promised that He would bring you joy.
He did not, however, promise you happiness
 as this world interprets it.
There may be many of you who will seldom find
 that kind of happiness.
It is because the latter is so often dependent
 upon the acquisition of very temporal things
 like material security, sensual pleasure, physical health—
 or the absence of sorrow and suffering in one's life.
While Jesus did not begrudge His followers
 temporal happiness, He warned them of the danger
 of making it the object or goal of their lives.
It is this kind of happiness
 that can suddenly turn into tragedy or despair.

This is not true of the joy that Jesus grants you.
He has come to fill your lives with eternal joy—
 and it is the kind of joy that persists
 even within and through the hours of sorrow
 and the pangs of suffering.
It is the joy of being loved and accepted
 as God's sons and daughters

by way of His gift of righteousness,
the joy of life eternal
by way of Christ's resurrection from the dead.

The receiving of this joy that Jesus grants
may well entail the denial
of some kinds of temporal happiness.
This kind of self-denial is never easy.
It is sometimes necessary to deny yourselves
some of the good and beautiful things of this life
in order to prepare the heart for the best
that God wants to give—or in order to communicate
His love and joy to others about you.
Whereas you may not have the right to continual happiness,
you, by God's gracious act of love through Jesus Christ,
have the right to eternal joy.
This joy is yours—even in the midst
of unfulfilled desire and of pain.
And no one can take it away from you.

John 15:11

Does Anyone Care?

*And He said to them, "Why are you afraid, O men of little
faith?" Then He rose and rebuked the winds and the sea;
and there was a great calm.*—Matthew 8:26

David, while hiding from King Saul in some dark cave,
seriously wondered if anyone cared about him.

Christ's disciples who once crossed the sea with Him
 wondered if He really cared about them
 when a great storm began to toss the boat around
 like a wood chip in a rushing stream.
Jesus rebuked them for their lack of faith in Him
 and proceeded to calm the storm.
Thus Jesus continues to lovingly rebuke you
 for allowing the tempests of your life to drive you
 to some morbid cave of self-pity and despondency—
 and there wondering
 if your great God really cares about you.

There will be storms in your life—this Jesus promises.
There will be pain and sorrow—
 this is as unavoidable with you as it was with Christ
 when He was in this world.
There will never, however,
 be a moment when God ceases to care about you.

Whereas God does not shield you
 from all the storms that come your way,
 He assures you that He is with you
 in the midst of those storms
 and that if you continue to follow Jesus Christ,
 He will keep them from destroying you.
Your God loves so deeply that He feels the hurt
 and the pain that afflict the lives of His children.
The raging storms, the conflicts, the problems
 that batter and beat upon all His creatures
 must also be confronted
 by His redeemed sons and daughters.
But He will soften the blow
 and eventually bring His peace and calm to bear
 upon the lives that have been wounded

by the sorrows and sufferings of this life.
He will grant the courage and strength
 to face and to overcome those hurts and pains.

David once concluded that "He delivered me
 because He delighted in me."
David's God will continue to deliver you—
 because you are the desire and delight of His loving heart.

Matthew 8:23-26; John 10:14-15

For Those Who Are Poor and Powerless

What About the Poor?

The Spirit of the Lord is upon Me, because He has anointed Me to preach good news to the poor.
 Luke 4:18a

If you are poor in respect to the things of this world
 and feel powerless under the unjust systems
 that seek to manipulate you and your loved ones,
 Jesus has something to say to you.
One of Christ's first sermons to His countrymen,
 at the beginning of His ministry to this planet,
 dealt with Isaiah's proclamation that God would send One
 who would seek out the poor to bring them good news
 and who would set free those who were the unwilling
 and suffering captives of unjust political systems.
Many who heard His message that day took offense
 and cast Him out of the synagogue.
They could not endure being reminded that the God of history
 was as concerned about the poor and the foreign widows
 as He was about the children of Israel
 and that He sent His prophets to minister to them.

God is your Father, and you are dear to His heart.
Like those people among whom Jesus walked and worked,
 there are multitudes today who honor His message
 but who are embarrassed and even offended
 by His concern for the poor and the oppressed of the world.
They have much to learn—or to regret

if they will not learn that their great accumulations
are, in part, the reason that large masses
of this world's inhabitants are poverty-stricken.
God, your Creator, has poured out His gifts
upon this world.
Yet He has allowed His creatures,
this world's human inhabitants,
the freedom to lust after riches
and greedily claim and accumulate things for themselves.
The heart of God grieves because so many of them
claim His name without sharing His concern
for those who are poor and powerless today.

Luke 4:16-30

Blessed Are the Poor

*And He opened His mouth and taught them, saying:
"Blessed are the poor in spirit, for theirs is the kingdom of
heaven."*—Matthew 5:2-3

It may be difficult for you who are poor
to accept the fact that the apparent riches
of many who worship Christ
are not nearly as important as they think.
Their accumulations may well be the very things
that keep them from entering the kingdom Jesus represents
and to which you are called.
They may never know that joy

for which all men and women were created—
the joy of knowing and relating
to their heavenly Father through Jesus Christ.
Some of them even assume that their material riches
are the result of their religious faith.
It is true that all good things come from God,
but His human creatures are capable of destroying
the very things that God gives
by keeping them for themselves
rather than using them for His purposes.
And they are used, often unknowingly and unwittingly,
to perpetuate poverty and oppression upon the world.

As strange as it may appear,
it is you who remain relatively poor
among the riches of your world
who are blessed in a very special way.
Your materialistic-minded peers may succeed
in hoarding this world's goods,
but they cannot cheat you out of the true, eternal gifts
that God offers to His children.
This is why Jesus came to you as a child born in poverty;
He worked God's miracles among the poor and powerless;
He chose as His followers those who had very little
in the way of material goods;
He died the death of a poverty-stricken criminal—
for your sins as well as the sins of the rich
and of those who oppress the poor.
You are already much closer to the kingdom of God
than most of the rich and powerful people
who live in this world.

Matthew 5:1-12

The Unfortunate Rich

The kingdom of heaven is like treasure hidden in a field,
which a man found and covered up; then in his joy he
goes and sells all that he has and buys that field.

Matthew 13:44

The kingdom of God is not obtainable
 through the efforts or the wealth of God's creatures.
It does not become acceptable—
 or in any sense comprehensible—
 until it is desired far more than anything
 or everything the world may offer.
The rich or well-to-do may build huge temples
 to the glory of God,
 but this does not bring them closer to the kingdom.
God gives the kingdom to whom He wills;
 He invites into His kingdom those who will
 to enter therein.
But only those who count God's love and saving grace,
 His gift of everlasting life,
 as of more value and importance
 than anything this world offers,
 and who are willing to leave all behind
 in order to embrace God's ultimate and eternal gift,
 will become a part of the kingdom of God
 that Jesus has come to proclaim and prepare for you.

It may be hard enough for the poor and powerless
 to become a part of God's kingdom,

but it will be well-nigh impossible for those
who have accumulated much of this world's goods—
except, that is, for the grace of God
that breaks through people's greed and teaches them
how to share their wealth and power with their sisters
and brothers in the human family.
Only the Spirit of God can work such miracles
in the hearts of men and women.

The poor have other obstacles that tend to distract them
and keep them from the gift of life
offered freely by the Father.
They may be fortunate in that they will not be hindered
by the finite wealth of the world as so many are—
even those who profess to be Christians
and claim to follow Jesus.

Matthew 13:44-46; 19:23-26

The Real Winners

But Abraham said, "Son, remember that you in your lifetime received your good things, and Lazarus in like manner evil things; but now he is comforted here, and you are in anguish."—Luke 16:25

You remember the story of the rich man and Lazarus.
The parable was an attempt to illustrate

that a person's status in this world is not indicative
of what his status will be in the new kingdom.
Though all rich people do not relish their power
or handle their wealth as did this rich man
in his relationship with Lazarus,
there are those who greedily obtain for themselves
everything they can get as if this world
and its rapidly deteriorating accumulations
were the sum total of life.
They will ultimately discover that there is another life
and kingdom they will have to take account of
and that the ephemeral thrills of this world are capable
of canceling out forever the supreme joy of the next.

You have missed out on the highly touted
and overrated thrills of opulence and overindulgence
in this sin-ridden world.
Nothing, however, save your failure
to embrace the God of eternal love
as revealed through Christ's life, death, and resurrection,
can stand in the way of His eternal riches
given even now but fully realized only in the new kingdom.
God has promised to grant you those things you need to exist
and what is necessary to carry out His will in your lives.
Even without the wealth and power that millions,
even those who call Jesus their Lord, persistently pursue,
you are the precious children of God
and you are the beloved disciples of Jesus Christ.

God, through His Spirit,
has endowed you with a power which,
though invisible to the power-seekers of this world,
is greater than either you or they can even dream of.
They may be able to build shrines and conduct

spectacular programs and win the plaudits
of the masses, but you, the comparably and apparently
poor and powerless of this world,
will win something far better—
the commendation of your Father in heaven.

Luke 16:19-26

Poverty Without Shame

*It is easier for a camel to go through the eye of a needle
than for a rich man to enter the kingdom of God.*
Luke 18:25

Jesus once sent His disciples out without money or baggage
 or even shoes on their feet—
 enjoining them to witness of the Father's love and
 the kingdom of God to those they met on the road.
They discovered that, even without material goods,
 they lacked nothing.
At another time Jesus informed a rich and powerful man
 who felt that something was lacking in his life that he,
 if he were truly to discover fulfillment,
 must give away all his riches and follow Jesus Christ.
Jesus pointed out to His disciples that the poor widow
 who cast her last few pennies into the temple treasury
 was giving far more than the wealthy religionists
 who dropped in their large pieces of gold.

To be poor or powerless is not necessarily honorable.
It may merely be the result of living in this world
 where humankind's greed prevents a fair distribution
 of God's abundant but limited gifts to the world's masses.
God, for the time being, allows this to happen,
 knowing that the careless misuse and waste
 of His gifts is depleting the rich resources
 of the world He created and is thereby
 bringing poverty to millions of its inhabitants.
God has His own way and time in which to bring
 judgment upon such carelessness and greed.
In the meantime, neither is poverty something to be
 ashamed of—except for those who contribute to it.
In fact, every man and woman is poverty-stricken before God.
It is the poor of the world who may be closer
 to that realization than those who are smugly ensconced
 in their materialistic enterprises
 and the worldly prestige these bring to them.
Thus it is that the kingdom of God belongs
 to the poor and powerless who embrace the invisible
 but eternal riches of God's saving grace.
As such they are, as sons and daughters of God's kingdom,
 wealthier and more potent than all the unregenerate
 creatures of this planet.

Matthew 10:7-10; Luke 18:18-30; 21:1-4

**For Those Who Are Waiting
for the New Kingdom**

The Kingdom of God Is Here

Whenever you enter a town and they receive you, eat
what is set before you; heal the sick in it and say to them,
"The kingdom of God has come near to you."
 Luke 10:8-9

To you who are waiting for the kingdom of God
 to come to you, the coming of Jesus Christ assures us
 that it is already here.
It remains a hidden kingdom for the masses of the world,
 but for those who recognize that Jesus has come
 from the Father and to those who accept Him
 as their Savior and King, the kingdom of God is a reality,
 and your allegiance to and participation
 in God's kingdom is an authentic and daily experience.
It is, furthermore, an everlasting experience.
An infant belongs to the parents that gave him birth
 and, though not consciously aware of it,
 is a full-fledged member of the family
 into which he or she was born.
Thus you who truly believe and have been baptized
 in Christ's name are, even without being fully aware
 of your relationship to God,
 citizens of His everlasting kingdom.

The kingdom of God is here.
It came to you through Jesus Christ; you enter it
 by embracing Him as your Savior from sin and death.

You are and will forever be citizens and subjects,
　　children and servants, of the kingdom of God.

It is as such that you are ambassadors and ministers
　　of God's kingdom—witnessing to God's saving grace
　　and Christ's redeeming love in loving relationships
　　and joyous proclamations to people around you.
Indeed, when you are near to them,
　　the kingdom is near to them.
They are not compelled to enlist in God's kingdom,
　　but will incur the judgment of God
　　if they persistently refuse to accept Jesus Christ.
There are those, however, who will recognize the new life
　　and kingdom through your faithful witness and who will,
　　as you did, become its citizens and servants.

John 5:19-24; Luke 10:8-9; 17:21

The Joy of Belonging

No one can serve two masters; for either he will hate the one and love the other, or he will be devoted to the one and despise the other. You cannot serve God and mammon.—Matthew 6:24

You belong to the kingdom of God.
Whereas you wait for that day
　　when it will be fully revealed and completely in control

of those evil forces that resist it in this hour,
you are members of that great, eternal kingdom now.
It is not necessary for you to indicate by pious attitudes
and actions your relationship to that kingdom.
You don't have to advertize that you have found it—
except when it is a loving witness that may attract others
who may want to know and experience it.
You no longer need to worry about the insecurity
of the worldly kingdom
in which you live and to which you are responsible.
You need not be overconcerned about the material
or physical needs of your life.
You dare not focus upon accumulating
the things of your world, lest such things blind you
to the importance and value of God's eternal kingdom
and His life and purposes for you.

You live within two kingdoms—
the eternal and righteous kingdom of God
and the temporal kingdom of your world.
While you have duties and responsibilities
to your worldly kingdom, and you have temporal needs
that must be attended to in your present human condition,
you need to be aware of your priorities—
that life on earth will make little sense,
its worldly offerings present little satisfaction or meaning,
unless your relationship to God's kingdom
is the most important thing in your life.
It is only when God and His purposes
are of prior importance in your life that these lesser,
worldly-kingdom matters will somehow fit into place.
Remember that in which you are rooted,
that to which you are committed,
that to which you belong forever.

Live for God and His kingdom,
 and all other things in your life,
 even the painful and sorrowful,
 will resolve in eternal joy.

Matthew 5:3; 6:1-34

God's Kingdom Revealed

Then the disciples came and said to Him, "Why do You
speak to them in parables?" And He answered them, "To
you it has been given to know the secrets of the kingdom
of heaven, but to them it has not been given."
Matthew 13:10-11

Only those who hear Christ's words and become His disciples
 will understand anything about the kingdom of God.
Only to them will God's Spirit reveal something
 of its mystery and might.
The unregenerate and unbelieving of your world
 are much too occupied with their foolish toys
 to comprehend anything about the immeasurable riches
 of God's kingdom.
And as long as they continue in that state,
 they will never understand His will for the universe
 or His purpose for their lives.

You, however, can know something about the kingdom
 that abides within you and about you.

Like seed cast into the ground,
 the kingdom of God has been planted in your midst.
Like good grain in the midst of obnoxious weeds,
 it grows all about you.
Like a precious pearl among the cheap trinkets
 that clutter up your world,
 it continues to exist in and around you.
It towers above the institutions and philosophies
 created and glorified by the small minds
 of earthbound men like a great, green pine tree
 above the desert chaparral.
It is salt in the midst of putrification,
 light amidst darkness, joy over against
 the cheap thrills that temporarily attract and amuse
 the multitudes.

Paintings cannot describe it; words cannot explain it.
Only the Spirit of God can imprint upon the human spirit
 something of its meaning and significance.
Only as you totally commit yourself to this kingdom
 as it is revealed and represented through Jesus Christ
 will it become real to you.
Only when God's purposes for your world are consummated,
 and space and time are absorbed by eternity,
 will His kingdom be fully revealed and known
 to His redeemed and adopted children.

Matthew 13:18-50

You Shall Live Forever

Truly, truly, I say to you, if anyone keeps My word, he will never see death.—John 8:51

Jesus spoke the truth to those who would listen
 when He walked upon this world.
Most of those who heard Him, however,
 did not really listen to Him;
 many were convinced that Christ was demonic,
 and they were ready to destroy Him.
Even the followers and friends of Jesus
 were deeply disturbed by some of the things He had to say.
He was, however, proclaiming the truth—
 and God, through the resurrection of Christ,
 provided ample evidence of that truth.

Even some of you, despite the many witnesses
 of Christ's miracles and resurrection,
 remain skeptical and uncertain
 about what God has done for you through Him.
What He promised then has already been granted.
It is the abolition of death and the gift of eternal life.
It is absolutely true: the sons and daughters of God
 shall live forever.
The atrocious event of death that threatens
 and appears to destroy what God has created
 becomes His very servant that swings open
 the gates to life everlasting.
Jesus has overcome death's evil intent and power
 by rising from the dead.

You are already citizens of the new kingdom.
This status does not change when you must close your eyes
 and leave behind the known and the familiar
 of your earthly existence.
You need not fear that ultimate event;
 it only guarantees that you shall hereafter
 know and experience fully the splendor and beauty
 of the new kingdom where death is abolished forever
 and where you can live and serve in supreme joy
 without the limitations and temptations
 of mortal life upon this earth.
Even while you cherish the life you endure or enjoy here,
 there need be no regrets in leaving it behind.
It is true:
 because you accept the life Jesus has come to bring,
 you shall live forever.

John 8:51; 11:25-26

You Have Nothing to Fear

*My sheep hear My voice, and I know them and they
follow Me; and I give them eternal life, and they shall
never perish, and no one shall snatch them out of My
hand.*—John 10:27-28

As God's beloved children you are to follow Jesus Christ—
 His life as your example,
 His teachings as your guidebook.

If God's will is to become your will for your life,
 then you will know that what Jesus says is from Him.
Jesus is your Lord and your Leader.
He will show you the way.
He is with you always—no matter how rough the road ahead
 or how tempestuous the elements about you.
You can rest assured that He will watch over you—
 as a shepherd watches his sheep
 or a mother her children.
You have received through Christ
 the gift of everlasting life.
It means that you are God's forever,
 that He will be your Guide forever.
You have nothing to fear.
There is nothing,
 save your own willful efforts to escape Christ's love,
 that can separate you from Him.
He will not coerce you to follow Him,
 but if following Him is your desire and will,
 nothing can stand between you and God's purpose
 for your life.
And His purposes have been revealed through Christ.
Do you not understand what this means?
You do not have to grope about in doubt and darkness.
You do not have to question your identity or validity.
You never need to feel alone
 or unloved or lost or insecure—
 whatever the world's cruel circumstances
 or humankind's atrocious accidents.
Nothing can alter your status and significance.
You belong to God,
 and Jesus is your Savior and Lord forever.

John 10:27-30

Waiting or Working?

Let your loins be girded and your lamps burning, and be
like men who are waiting for their master to come home
from the marriage feast, so that they may open to him at
once when he comes and knocks. Blessed are those
servants whom the Master finds awake when He comes.
 Luke 12:35-37a

While there are many of God's children who are watching
 and working for the advancement of the kingdom of God,
 there are multitudes who are committed to waiting only.
They are like those groups of people
 in the early days of the church
 who pulled out of the mainstream of public
 life in order to create communities of waiting people—
 expecting that Christ would soon return
 to deliver them once and for all from the pressures
 and temptations of their sin-ridden world.
These, and the scores of confessing Christians in this day
 who ignore their responsibilities to the human family
 in their attempts to save themselves
 from the dangers of risk and pain,
 may be calling Jesus their Lord
 but they are not acting like His servants.
They create for themselves snug harbors that shield them
 from life's storms and will hopefully keep them
 from becoming tainted by the evil world about them.
They separate themselves from their sisters and brothers
 and, in effect, are self-serving and thereby self-centered

rather than the communicators and transmitters
of Christ's love and healing
to the brokenness about them.

You are to be reminded that the kingdom of God
 is already in your midst.
Jesus has promised to return
 and ultimately to fully reveal that kingdom,
 gathering into its portals the faithful
 from the past, present, and future generations.
This has not yet taken place;
 it may not happen in your lifetime.
But happen it will.
When this great event does take place,
 it will catch millions unaware
 and unprepared to enter into the kingdom.
There will be scores of others, avid religionists,
 confessors and professors of the Christian faith,
 who have been anxiously awaiting the great event
 but who have contributed almost nothing
 toward preparing others
 for what Jesus promised would take place.

You are to be aware of Christ's final return and revelation,
 to watch for it, to welcome it,
 even while you are obediently active and fruitful
 in the process of serving Him by serving the citizens
 of the world around you.

Luke 12:35-48

The Joy of Serving

It is like a grain of mustard seed which a man took and sowed in his garden; and it grew and became a tree, and the birds of the air made nests in its branches.—Luke 13:19

Like a small seed that grows into a large,
 branch-waving tree,
 or a little leaven that permeates a whole loaf,
 so the kingdom of God, often invisible to your eyes,
 apparently insignificant and of little note
 in the eyes of the world, is on its way to becoming
 the greatest happening the universe has ever witnessed.
Again, as with seed or leaven,
 the phenomenon of growth within God's kingdom
 does not depend wholly upon your efforts.
Whereas your contributions are significant,
 the essential growth of God's kingdom is accomplished
 by way of God's Spirit who,
 through Christ's word and witness as related by you,
 invisibly but profoundly touches and transforms
 the lives and spirits of the human creatures around you.

You are responsible, as God's children
 and as Christ's followers and servants, for sowing the seed,
 or injecting leaven into the lump.
You are to do this through loving deeds
 and joyous proclamations
 through which God's life and Word
 are sown in the hearts of individuals who cross your paths.

You can do little more than this—nor are you expected to.
The invisible leaven of God's Spirit will permeate
 the lives of those who respond to His Word of life
 as reflected in your lives,
 and will thereby draw people into His kingdom.
There is no way in which you can convert people
 or coerce anyone to enlist in God's kingdom.
Beware lest you unwittingly assume the Holy Spirit's role
 of drawing people to God and His kingdom.
The Spirit of God seeks to use you;
 He will not, however, bless your attempts to use Him
 in order to accomplish your objectives
 or further your goals.

The joy of serving God is yours;
 the glory of large or small successes
 in the course of such service is God's.
The celebrated consequence is the growth and advancement
 of the kingdom of God in your world today.

Luke 13:18-21

Are You Ready?

The kingdom of God is not coming with signs to be
observed; nor will they say, "Lo, here it is!" or "There!"
for behold, the kingdom of God is in the midst of you.
 Luke 17:20b-21

The kingdom of God cannot be measured by statistics
 or pictured through surveys and graphs—
 though many religious leaders persist in attempting
 to identify and communicate their success by such methods.
While you struggle in vain
 to realize some tangible evidence of the kingdom—
 for something to point people to
 in the effort to lead them to God—
 remember that you, as God's redeemed sons and daughters,
 are of that kingdom; it is present within you.
It is necessary, therefore, that you be wary
 of those self-ordained prophets who try to sell you
 some nonsense about knowing where the kingdom is
 or when it will appear.
They are phonies—or sincere but deluded fools.
The kingdom will be fully revealed in God's own time.
Christ shall make it known at that time and there shall
 no longer be any doubts as to the fact and nature
 and eternal presence and power of God's kingdom.

Until that great day, however, things will continue
 much as they now do—farming, building, marketing,
 rearing children, schooling, pleasure-seeking,

money-making, love-making, joy and sorrow,
 peace and war, greediness and goodness.
Of this you can be sure: for the vast masses
 of this world's inhabitants, the final revelation
 of the kingdom will come suddenly and surprisingly,
 with many of this world's human creatures
 utterly unprepared to greet it and embrace it.

It need not be that way with you.
God has through Christ's coming, His teachings,
 His death and resurrection,
 prepared and introduced you to that kingdom.
Because you are even now a part of that kingdom,
 you, if you continue to wait and watch in faith
 and serve in love, will always be ready
 to welcome its revelation with joy.

Luke 17:20-37

When Faith Endures

*Who then is the faithful and wise servant, whom his
master has set over his household, to give them their food
at the proper time? Blessed is that servant whom his
master when he comes will find so doing.*
 Matthew 24:45-46

It is Jesus' profound concern that not one of you
 should abdicate the kingdom

into which you have been received.
There will be many temptations.
Siren voices will reach out to you,
 seducing, deluding, seeking to lead you astray.
The world will continue to be wracked by cataclysmic events.
Governments will fail; traditions will be nullified;
 customs and mores will change.
There are catastrophes affecting the lives of millions
 of the world's inhabitants in this very moment;
 persecution, torture, imprisonment, even death
 is the lot of scores of God's children even now.
It is not surprising that many who would follow Jesus
 are betrayed by the false promises
 of temporal peace and comfort,
 even of material wealth and boundless health,
 that are handed out by leaders Christ has not chosen,
 who are twisting His teachings into claims
 He never intended.

This world will never be transformed
 into the kingdom of God.
Nor will it become an eternal oasis of glory and light.
It is subject to death,
 and is even now dying in its iniquity.
Only those of you who faithfully follow Christ
 will live forever.
Yet even you shall suffer within this suffering world.
There will, at times,
 be excruciating pain and agonizing sorrow.
This was Jesus' lot when He lived as man in this world.
It is and shall be, in some measure, your lot and affliction.

It is those whose faith endures all this to the end
 who can be assured of salvation.
You don't have to be afraid of whatever will happen

to you or to this world.
Christ guarantees,
 though He does not reveal the day or the hour,
 that these terrible things that transpire in the world
 will come to an end.
You shall live forever in the joy and glory
 of God's eternal kingdom.

Matthew 24:1-44

Watchful, Expectant, and Obedient

> *Then the King will say to those at His right hand, "Come, O blessed of My Father, inherit the kingdom prepared for you from the foundation of the world; for I was hungry and you gave Me food, I was thirsty and you gave Me drink, I was a stranger and you welcomed Me."*
> Matthew 25:34-35

Do not be anxious or afraid about what is happening
 in this world.
Instead be watchful, expectant,
 for even through the evil that exists about you,
 and in the hearts of people around you,
 God is working out His purposes.
The very sufferings that afflict you are,
 in effect, preparing you for the great new kingdom
 that you have inherited.

Nevertheless, as you faithfully watch and wait
 for the final ingathering and revelation of that kingdom,
 you are enjoined to faithfully serve—
 to dedicate your lives and talents and possessions
 to the accomplishment of God's purposes in this world.

You are to serve that kingdom
 by serving God's creatures around you.
The new kingdom Jesus has established in your midst
 is the kingdom of love, and that love is extended
 through you to your fellow beings.
Inasmuch as you serve them, you are serving Christ.
The simple but profound acts of feeding the hungry,
 bringing cheer and hope to the ill,
 accepting in love the stranger,
 and showing concern for the imprisoned
 are done for Christ and for God the Father.
In may well be most difficult to take sides
 with the poor and oppressed, the maligned and abused,
 even against the very powers
 that have benefited your material existence;
 but in doing so you may be serving Christ's purposes
 and accomplishing His objectives.
It is those indifferent, self-centered people
 who care for little else
 than their own material and physical welfare
 who are farthest from the kingdom of God—
 and who may become the very enemies of God.

The kingdom of God is in your midst.
It will, in God's own time, be fully revealed.
As you are aware of it, expectant about it,
 and working to extend its love and power

among your fellow persons, you are prepared
to welcome its fulfillment and to embrace its Christ
as your Lord and King forever.

Matthew 25:31-46

For Those Who Aspire to Leadership

So You Want to Be a Leader

But Jesus said to them, "You do not know what you are asking. Are you able to drink the cup that I drink, or to be baptized with the baptism with which I am baptized?"
Mark 10:38

Some of you are called to be leaders
 within the new kingdom that Jesus represents
 and which He inaugurated in your midst.
Beware lest you take the appointment lightly.
It by no means increases your status in the eyes of God;
 it does not make you more significant
 than His other children.
Nor is it something you should selfishly aspire to
 or even assume to be your calling as Christ's disciples.
Be wary of those inner desires to be king-of-the-hill,
 to be prominent or important, to be regarded
 as someone special in the eyes of your peers.
Only those who are gifted and empowered and chosen
 by the Spirit of God will be granted the courage
 and strength—and the humility—to properly
 and effectively carry out the assignments of leadership.
Do not seek the appointment to leadership;
 let the appointment, if it is of God, seek you out.

You are all called to be the ministers and servants of God.
Jesus has set the example, and His Spirit daily grants you
 the grace to live and act as such.

You all have roles to play and parishes to serve
in the grand business of proclaiming and advancing
God's kingdom in this world.
Even while you minister in love to your fellow beings,
and witness to them concerning God's eternal love,
you are fulfilling God's will for you
even if such loving service
is not recognized and applauded by others.
The important calling of your life
is to be faithful to God,
and you are expected to carry out that calling and ministry
right where you are.

You do well to remember that leadership
will place upon you responsibilities and demand sacrifices
you may not be willing or able to assume.
Be reluctant about accepting the mantle of leadership—
unless God Himself places it upon you.
Then be recklessly courageous about serving God
wherever He leads you
and in whatever He commands you to do.

Mark 10:35-40

Leadership Versus Servanthood

But whoever would be great among you must be your
servant, and whoever would be first among you must be
slave of all.—Mark 10:43b-44

In the eyes of the world, leadership is usually associated
 with power and prominence;
 it is often sought after by very egocentric people.
Such people desire to be coddled, even idolized;
 they want authority, and they enjoy lording it
 over their constituents; they want to be served by them.
This is not so in Christ's kingdom.
The kingdom of God is served and promulgated by those
 who serve others, whose leaders are those
 who become the servants of all.
It is true that you are enjoined to follow Christ,
 to serve Him, but this was possible only
 after He served you and His Father
 by reconciling you to your Creator.
As Jesus has been your servant,
 so you are made His servants,
 and you serve Him by serving
 your brothers and sisters in the human family.

This is especially true of those
 who are chosen to be leaders;
 their greatness or effectiveness is determined
 by the quality of their servanthood.

God sent Jesus to this world
 for the purpose of giving His life for you
 and for all the inhabitants of this planet.
It is because of this that Christ is your leader
 and claims lordship over those who become His disciples.
Those who are authorized to proclaim Christ's Word
 and teach His precepts do so as His servants,
 and they serve their fellow creatures
 in the process of doing so.
Jesus has exhorted you who aspire to leadership
 to regard such servanthood as more important
 than your very lives,
 to carry out your service without concern
 for consequences and with even less concern
 for accolades or accommodations.
It is those who lovingly serve in this manner who,
 even without official appointment or recognition,
 become the real leaders in the kingdom of God.

Mark 10:42-45

Feet-Washing Servanthood

And He sat down and called the twelve; and He said to them, "If any one would be first, he must be last of all and servant of all."—Mark 9:35

When you aspire to some position of leadership,
 mark well Christ's example as your Lord and Master.

As Jesus did not hesitate to perform
 the humblest act of service on behalf of His followers,
 so your Christian leaders ought to emulate Him
 and realize that the humblest and most unpretentious act
 of loving service toward their constituents
 is service to God and His kingdom.
While the leaders of this world often seek their ends
 through coercion or manipulation, bribery or compromise,
 the leaders of Christ's kingdom
 accomplish their objectives by way of self-sacrificing love.
Jesus is not recommending or guaranteeing that this kind
 of leadership will bring worldly glory or success.
Indeed, the world will regard such activities
 as very foolish, even cowardly and impotent.
Even many who profess Christ's name are more attracted
 by strong, authoritative, spectacular activities
 which they associate with true leadership.
These may titillate the imaginations and loyalties
 of many people;
 they seldom bring people into the kingdom,
 nor do they please the heart of God.

Jesus did not call His disciples to positions of leadership;
 He sent them forth to be the servants of the kingdom
 by serving their fellow beings.
In the process of doing this, most of them were guided
 by His Spirit into positions of leadership.
They followed the example Christ set before them—
 many of them literally losing their lives
 in the process of serving humanity
 by proclaiming and demonstrating His redeeming love.
Nor does Jesus call you to be leaders;
 He calls you to be servants—
 to lovingly stoop even to the feet-washing level

of your neighbor's needs—
that God's infinite love may be revealed through you.

John 13:1-20; Mark 9:35

Beware of Greatness

Whoever humbles himself like this child, he is the greatest in the kingdom of heaven.—Matthew 18:4

The principles of the kingdom Jesus represents
 appear to be paradoxical to the kingdoms of this world.
Indeed, they are.
Whereas the multitudes of this world are attracted
 by physical prowess, mental capacity, material wealth,
 or by those talents that entertain or inspire or stimulate,
 true greatness, as presented and interpreted
 within the kingdom of God,
 begins with the open, honest, trusting heart
 of a little child.
Thus the purposes of God will be served far better
 through the unostentatious, unassuming,
 yet caring, loving lives of men and women
 who follow Christ's example of servanthood
 than through the arrogance of self-ordained leaders
 who succeed in drawing masses of people into their fold.

Every flock must have a shepherd.

While Jesus is the Good Shepherd
 sent by His Father to gather together His kingdom,
 some of you may be chosen to be undershepherds
 who are responsible, as Christ's servants,
 for teaching and leading people
 in the way He has set before you.
As Christ, the Great Shepherd, laid down His life
 for you and for all who will follow Him,
 so you are to serve your brothers and sisters
 with that kind of love and concern.

If you are faithful leaders of the people of God,
 He will do great things through you.
The truly great things He does may not be visible to you,
 but God sees and knows.
Do not be concerned about visible results—
 which may be withheld from you
 lest you accept credit for them unto yourselves.
You are not to seek greatness.
You are to be concerned about and grateful
 for your personal relationship to Jesus and the Father,
 the fact that you are forever God's children and servants.
May that be the ultimate source and goal of all your joy.

Matthew 18:1-4; Luke 10:17-20; John 10:14-15

Every Christian a Servant

He who is greatest among you shall be your servant;
whoever exalts himself will be humbled, and whoever
humbles himself will be exalted.—Matthew 23:11-12

In this world the crown of leadership
 is usually given to those who are "winners,"
 who are gregarious and aggressive,
 who sell themselves as persons of capacity and insight,
 who possess special gifts or abilities that promise
 to grant pleasure or security or problem-solving techniques
 to those who follow them.
This was true when Christ walked among God's creatures
 on this planet; it would be equally true if He were
 man-born-of-woman among you today—
 few of this world's multitudes would accept Him
 as their leader.

If you are delegated leadership
 as a result of your aspiring or striving,
 it is a precarious position that you assume.
Those who are truly led by the Spirit of God
 into positions of leadership will often be considered
 to be "losers" by the world-at-large.
This is because they follow Jesus Christ,
 and His leadership is synonymous with servanthood.
It is because they, rather than resolving
 the conflicts and problems of this world,
 point to the new kingdom and to their God, who alone

can resolve the conflicts and struggles of humanity.
Rather than promoting themselves and their own glory,
 they lead people in glorifying God.
Instead of promising people success,
 they challenge them to make sacrifices;
 instead of comforting them
 in their self-centeredness and apathy,
 they provoke them into accepting responsibility
 for the poor and less fortunate about them.
Instead of being the leaders of people,
 they take the lead in being servants to people—
 seeking to lead them into spiritual fulfillment,
 as well as responding to their physical needs.
This is because they are lovers of people
 rather than masters of people, and they dedicate
 themselves to communicating, in word and deed,
 God's saving love and grace to His creatures about them.

In this manner and measure
 you are all called to be leaders and teachers,
 servants of your heavenly Father.

Matthew 23:1-12

**For Those Who Question
the Divinity/Humanity of Christ**

God and Man

*And when Jesus was baptized, He went up immediately
from the water, and behold, the heavens were opened
and He saw the Spirit of God descending like a dove, and
alighting on Him; and lo, a voice from heaven, saying,
"This is My beloved Son with whom I am well pleased."*
Matthew 3:16-17

It would appear that many of you
 still do not know who Jesus Christ really is.
To some people He is God made visible,
 an apparition of sorts that appeared upon the world
 for a short period of time only to ultimately return
 to His eternal throne in some distant universe.
To others Jesus is a person of illegitimate beginnings
 who became a teacher and a prophet, a Jewish mystic who,
 on behalf of the poor and outcast, dedicated His life
 to creating a religion of peace and goodness,
 or a radical rabbi determined to overthrow
 the foreign oppressors of the Jews
 as well as their corrupt religious leaders.
To many who stood against Christ in His day
 He was some kind of a magician who possessed
 demonic powers or a dangerous false prophet
 who dared to claim divine origins.

The fact is, Jesus is the Son of God and man-born-of-woman.
God Himself bore witness to His true identity
 as His beloved Son.

So did the devil who, knowing that Christ came from God,
 and knowing, as well, His status as man-born-of-woman,
 attempted in vain to short-circuit His ministry
 by tempting Him to utilize His divine power
 for selfish purposes—like turning stones into bread
 with which to feed Himself, or gathering a following
 by performing supernatural feats,
 or winning the world without suffering or dying,
 by acknowledging and submitting to
 Satan's dark and destructive powers.

Jesus Christ is truly the Son of God;
 yet, because He was man-born-of-woman,
 these were strong temptations.
He was sorely tested when His human body ached
 with hunger after weeks of fasting,
 and His human spirit became fatigued as He was confronted
 with the price He would have to pay in introducing
 God's kingdom to a world of sinful creatures.

As Son of God and sent by God,
 Jesus knew what His Father willed,
 and He determined to do what He had to do,
 for He had come in order that,
 even through suffering and death,
 He might grant life and joy to a dying world.

Matthew 3:16—4:11

Son of God—Man-Born-of-Woman

Again the high priest asked Him, "Are you the Christ, the Son of the Blessed?" And Jesus said, "I am; and you will see the Son of man seated at the right hand of power, and coming with the clouds of heaven."—Mark 14:61b-62

Jesus Christ is, indeed, the Son of God.
This was His answer to the high priest's question
 during His trial before the religious leaders of His day.
This is His answer to the religious and nonreligious
 people of the world.
For this reason Christ was crucified.
In thought and intent, that betrayal and crucifixion
 continues even within some
 of the fine religious institutions of this day.
It was as God's Son and as man-born-of-woman
 that He came to the world with the glorious message
 of God's love.
It was as such that He made possible your redemption
 by His death and resurrection.

To this very hour it is true
 that those who refuse to accept Jesus Christ as Son of God
 refuse to honor the Father, God Himself.
The prophets of old announced the coming of Christ;
 John the Baptist bore witness as to His having come;
 the disciples from that time until this have,
 at the risk of their lives,

proclaimed Christ's salvation and His lordship
over the kingdom of God that is in your midst.

The words Jesus spoke, the acts He performed,
are the words and acts of His Father,
and they prove that He has come from God.
Everything He did was by God's authority alone.
The life He brings to you is God's life, eternal life,
and those who believe in Christ believe in God
and are the recipients of that life.
Jesus does not bear witness to Himself,
but to His Father.
Those who receive His witness,
who come to Him as He is revealed through the Scriptures,
they come to God and are received by Him
into His eternal kingdom.
You have not and you will not hear God speak—
except as He has spoken through Christ.
Jesus said truly: "I am the Way and the Truth
and the Life; no one comes to the Father but by Me."

Mark 14:61-62; John 5:19-47; 14:6-24

They Knew Him as Man

Now some of the scribes were sitting there, questioning in their hearts, "Why does this Man speak thus? It is blasphemy! Who can forgive sins but God alone?"

Mark 2:6-7

Jesus upset some of the religious people during His ministry
 when He said to the paralytic that was brought to Him,
 and, at another time, to the woman
 who bestowed her affection upon Him,
 "Your sins are forgiven."
The bystanders were outraged;
 "Only God can forgive sins," they announced
 with anger in their voices.
They were right in their understanding that God alone
 can forgive the sins that His creatures commit
 against Him and their fellow beings.
They were wrong, however, in not accepting Christ
 as having been sent by God, as the Messiah,
 the very Son of God.

In the instance concerning the paralytic,
 Jesus further witnessed to His divine origin
 by miraculously healing the man of his incurable disease.
In the instance concerning the woman,
 His humanity was made obvious as He gratefully
 received her act of love that was performed upon Him
 in the presence of His followers.

As far as the people of that day,
　　including Christ's faithful followers, were concerned,
　　there was no question as to His humanity—
　　that He was man-born-of-woman.
They caught only glimpses of His divine nature
　　from time to time;
　　only three of His disciples were allowed to witness
　　the transfiguration event on the mountain.
His human nature was apparent to them as they walked
　　with Him and were aware of His human reactions
　　to events about them.
While Peter, inspired by the Spirit,
　　boldly declared Christ's divine origin
　　and many accepted Him and followed Him
　　as a man sent by God,
　　their loyalty was in great part to a man who they hoped
　　would make Israel a great nation again.
Not until Christ's resurrection
　　after His followers witnessed His dying on the cross,
　　did they, assured by the Spirit in their hearts
　　that He truly was the Son of God,
　　see Him fully as the living Christ.
What a difference it made in their lives
　　when they finally accepted Jesus Christ,
　　not only as man-born-of-woman,
　　but as God's beloved Son sent to reconcile
　　the creatures of this world to the kingdom
　　of His Father, God!

Mark 2:5-12; Luke 7:44-50; Matthew 16:13-23

He Was Revealed as Divine

Jesus said to them, "Truly, truly, I say to you, before
Abraham was, I am."—John 8:58

While Jesus never sought for self-glory in His time
 upon this world, He spoke the truth to those
 who questioned His identity.
The recognition of His Father in heaven was enough
 for Him even though, as man-born-of-woman,
 He was tempted by the forces of darkness
 to accept adulation and accolades for Himself.
Christ's rightful insistence that He came from the Father
 and, in truth, existed even before Abraham,
 the ancestral father of the Jews,
 incensed the religious leaders.
This promoted and propelled their plans
 for His eventual and violent exodus from this world.

Because Jesus was man-born-of-woman,
 He suffered, He tired, He hungered;
 He was hurt by the people's continued refusal
 to accept God's love as revealed through Him.
As Son of God He knew well that most of the people
 to whom He ministered would resist His revelation
 of God the Father and that He would have to suffer
 and die for the sins of the world.
Even though He knew
 that God would be glorified through this—
 and would raise Him from the dead—

the pain and shame and loneliness of the cross,
and the inability of even His dearest friends
to understand and support Him,
was almost humanly impossible to bear.
Christ's suffering and death verified His humanity;
the resurrection from the dead proclaimed His divinity.
His close followers put the pieces together
and emerged from those desperate hours
as victorious leaders of the new kingdom.
You are now God's chosen ones appointed to live out
the truth and power, the life and joy,
the redeeming and reconciling love of the Father
as it has been revealed through Jesus Christ,
the Son of God and man-born-of-woman,
God-incarnate, who now dwells in you,
His disciples and His servants, forever.

John 8:53-58; 12:26-36

Believe in Christ—Believe in God

*And Jesus cried out and said, "He who believes in Me,
believes not in Me but in Him who sent Me. And he who
sees Me sees Him who sent Me."*—John 12:44-45

Jesus insisted that He was not the Father;
He was the Son of His Father-God.
God has come to you through Christ, man-born-of-woman.

As you hear His words, you hear the words of God the Father.
When you plant your faith in what Christ has done and said,
 you have faith in God—receiving Him
 and His gracious, forgiving, redeeming love through Christ.
His words declare God's salvation,
 and they declare God's judgment upon those
 who refuse to accept His salvation through Jesus Christ.
The gift of everlasting life that God offers
 is granted through His Son.
Those who refuse Christ—His words and deeds—
 refuse the Father who sent Him.

When you pray to God, you pray to Him
 as He has been revealed to you by Jesus Christ.
As you serve God, you serve Him by obeying Christ's words,
 spoken by God's authority, and by emulating Christ's life
 as He lived and served in this world.
Christ is not the Father;
 He spoke and acted, ruled and judged
 as authorized by the Father.

You cannot fully comprehend this amazing thing
 that God has done in your midst.
Enough has been revealed, however,
 to enable you to believe, to trust,
 to live in loving obedience to God and His will for you.
The day is coming,
 and that time is known only by the Father,
 when He shall visibly return to this world
 and gather you into the great, eternal kingdom of God.
Then the dimness of your finite minds will be removed,
 the obstacles of your mortality eliminated,
 and you will understand and rejoice fully
 in the presence of God and His Son, Jesus Christ.

Until that day, Christ is with you through His Spirit,
 the Spirit of God,
 who will comfort, counsel, and guide you
 upon the paths He has set before you.

John 12:44-50; Mark 13:24-27

For Those Who Would Follow Christ

Called to Serve

*I sent you to reap that for which you did not labor; others
have labored, and you have entered into their labor.*
 John 4:38

Jesus' first disciples soon became aware
 during His ministry with them,
 that the foremost objective of His life
 was to accomplish the purposes of His heavenly Father.
This was, indeed, more important to Him
 than eating or drinking or sleeping or anything else
 that He was to experience upon this world.
Though their priorities were initially
 much different from Christ's, the disciples ultimately
 recognized His mission to be their mission
 and, after His resurrection,
 it became as important to them as it was to Jesus Christ.

Whereas the citizens of this planet are likely to label
 such devotion to Christ's cause as religious fanaticism,
 He expected this kind of devotion
 from those who followed Him.
This may be the reason that,
 whereas there are many worshipers,
 there appear to be few followers.
God has blessed the world with beauty and abundance;
 you are, as His beloved children,
 to receive His gifts and to enjoy them.

They are not, however, to assume priority in your lives—
 any more than the gifts that children receive from their
 parents are to be more important to them
 than the parents themselves.

Thus your eternal Parent expects the loyalty
 and obedience of His children.
You are to sow the seed of His kingdom all about you;
 many of you will be privileged to reap the fruit as well—
 to help gather in the results of that
 which has been sown.
The task is gigantic; the laborers, the true disciples
 of the Master-Sower, are few.
Most of those who have been called
 to labor for God's kingdom are too busy
 building and establishing their own little kingdoms.
If you are to follow Jesus Christ,
 His kingdom, which is the kingdom of His Father,
 must be your primary concern.
If this is so,
 you will discover far more joy and contentment
 in your lives as God's faithful servants
 than will the masses of your world
 who labor only for themselves.

John 4:31-38

Eternal Investments

*And He called to Him the multitude with His disciples, and
said to them, "If any man would come after Me, let him
deny himself and take up his cross and follow Me. For
whoever would save his life will lose it; and whoever loses
his life for My Sake and the Gospel's will save it."*
 Mark 8:34-35

You have been informed that, as God's beloved children,
 you are the recipients of His eternal grace.
And so you are; Jesus has brought that grace to you;
 He became your righteousness before a holy God;
 you are His forever.
Now you who are made God's children and who bask joyfully
 under His shepherdlike care are called and assigned
 to servanthood—to become givers as well as receivers—
 to transmit, communicate, channel God's love and grace
 to humankind about you.
As God revealed His love for you through His self-denial
 and sacrifice—and through His children who with care
 and concern brought His life and message to you—
 you are elected and appointed to bring it
 to others in your path.
As it did for Jesus, so for you,
 this will demand self-denial and cross-carrying.
Cross-carrying means caring—for other people.
It means that you cease making yourself and your needs
 the very center of your lives and allow that center
 to be occupied by others;

that you cease coddling the burdens you have to bear
and reach out to share the burdens
of your sisters and brothers.

It is not easy; indeed, it is often very painful,
 and the courage and strength to do this must come
 from God and His Spirit within you.
This is, nevertheless, what is involved in following Jesus.
Those who live primarily for themselves
 are not living at all;
 they are the real "losers" in this world.
Those who live, make sacrifices, and bear crosses
 on behalf of others are the "winners," the gainers,
 and they are investing in immortality and eternity.
They shall live forever.

What you are willing to do for your children and loved ones
 you are now expected to do
 for God's creatures all about you,
 for they have all become your children
 and your loved ones
 just as every human being is the object
 of Jesus' love and concern.

Mark 8:34-38

The Risk of Discipleship

Foxes have holes, and birds of the air have nests, but the
Son of Man has nowhere to lay His head.—Luke 9:58

It is not difficult to make beautiful,
　　generous statements in the excitement and ecstasy
　　of some new commitment.
The expressions of gratitude and the pledges
　　of love and loyalty that result from some revelation of
　　or insight into God's redeeming love
　　are precious indeed.
They are, nonetheless, often shallow and immature.
There are so many who accept Christ as Savior and Redeemer
　　and verbally, at least, honor Him as Lord,
　　who never mature into disciples.
Apart from being personally solaced and comforted,
　　the lives of these people never change very much.
They have never really become Christ's disciples
　　and servants.
They are obviously not ready or willing to pay
　　the price involved in the matter of discipleship.

Of course there is a price to pay—
　　or so it seems to you who have never, as Christ did,
　　beheld the glories of God's kingdom.
Because you have not seen nor can possibly comprehend
　　the full meaning of your redemption
　　and the life that awaits you, the things of this world,
　　though they are trinkets

when compared to what is in store for you,
 are still very important.
Discipleship involves a risk—
 or so it will appear in your eyes.
Jesus can at this time only assure you
 that it is a risk worth taking.
You have nothing to lose and everything to gain
 in following after Him.
If you really believe in Him you will,
 inspired and encouraged by the Holy Spirit,
 fling caution to the winds and dare
 to trust in His words and to obey His commandments.
He does not guarantee perpetual happiness
 or ecstatic feelings.
He promises, instead, that there will be conflict and pain,
 heavy burdens and difficult times.
He promises, as well, Jesus does, that you
 will never be alone—that He is with you always
 and will grant you His joy.

Luke 9:57-62

Servanthood Means Involvement

*Behold, I send you out as sheep in the midst of wolves; so
be wise as serpents and innocent as doves.*
 Matthew 10:16

God came to you through Jesus Christ.
It was in this manner that He became involved

in your agonies and crying needs—
even to the point of bearing your sins
and receiving upon Himself their guilt and consequences.
It was because of that involvement that He found you
and redeemed you—drawing you to Himself
and His kingdom.
This involvement continues in your world
through those who follow Christ.
Jesus has set the pace; He expects His disciples
to keep it.
You are to become involved in humankind's crying needs,
to become identified with people
in their sorrows and joys.
You do this as the servants of Jesus Christ,
and in doing so you represent Him.
Infilled with His love, you are to reflect
that love and concern to others about you.
It isn't enough to condemn the distortions of humanity
from the pulpits and pews of your churches;
you are elected to become involved in the blood and tears,
the hurts and sufferings, the oppression and deprivation
of God's creatures on Main Street or in marketplace,
in suburb and ghetto, wherever they may be found.
Because you are already involved in the sickness
of this world, you must, if you follow Jesus,
now become involved in its cure.

This will not be convenient or comfortable.
It might even be dangerous.
You may have to risk reputations, wealth,
your status in society, even your very lives,
in this involvement.
Following Jesus, however, requires this kind of involvement.
As He suffered on your behalf, you are expected to suffer

on behalf of others for His sake, to lose your lives
in service to them only to find them anew
in the incomparable joy of being the sons or daughters
of the living God and His loyal disciples and followers.
"As the Father has sent Me, even so I send you,"
Jesus once said to His disciples.
This is what He is saying to you.

Matthew 10:5-33; John 20:21

Effective Evangelism

> Whatever house you enter, first say, "Peace be to this
> house!" And if a son of peace is there, your peace shall
> rest upon him; but if not, it shall return to you. . . . Heal
> the sick in it and say to them, "The kingdom of God has
> come near to you."—Luke 10:5-6, 9

You are well aware that God is not confined
 to your church sanctuaries and altars.
While your worship gatherings are important
 and not to be ignored, your most effective service
 as Christ's followers will be carried out
 during your Monday-through-Saturday contacts
 with your fellow beings on the streets,
 in offices and classrooms, workshops and homes.
Before you can effectively proclaim the Gospel
 of His love and the presence of the kingdom,

you must identify and relate to people where they are.
This means that you become friendly with people,
 listen to them—their joys and their sorrows,
 minister to them at the point of their greatest need,
 share with them of your abundance,
 receive from them what they desire to share with you.
If you do this out of genuine, God-inculcated love
 for these people, the time will come
 when you can announce
 the presence of the kingdom and the love of God
 as revealed through Jesus Christ,
 their Savior and Redeemer.
Or, through your faithfulness,
 you may have prepared the way for others to make
 that all-important announcement.

Of course, there are dangers and risks.
You are, indeed,
 exposed like "lambs in the midst of wolves"
 to the scorn and hostility of those
 who are not ready or able
 to accept you or the God you represent.
It is a hard, rough road that Christ urges you to travel.
He has called you, however, to follow Him.
This means that He has gone before you
 and will continue to lead you.
It means, as well, that Jesus will grant you
 the strength to endure, and promises you joy
 in the midst of suffering,
 and always holds before you the assurance
 of ultimate victory.
And remember, He is with you at all times.

Luke 10:1-12

This Is Revolution

*I came to cast fire upon the earth; and would that it were
already kindled!*—Luke 12:49

While many who claim Christianity as their religion
 interpret Christ's coming into the world
 as the only hope for universal peace
 and as a promise of eternal security,
 Jesus would remind you who truly want to follow Him
 that His coming was for quite another reason.
The Gospel He brought is radical;
 the kingdom of God that He introduced
 and to which you subscribe is revolutionary.
It was so radical to the Jews of His day that they
 cast Jesus out of their synagogues
 and eventually executed Him on a cross.
The Gospel ascribed to Christ today
 and as proclaimed in many of your churches
 has become refined and respectable.
It has consequentially become diluted and impotent.
It has succeeded in bringing healing to some,
 contentment to others, and the promise
 of God's forgiveness and everlasting life to all,
 but it has failed to change the hearts
 of most of those who feign acceptance
 and therefore appears to have little effect
 on the world at large.
The reason is obvious:

most participants of the Christian faith
have tempered the Gospel
to fit their own superficial needs and desires
without the threat to their comforts and conveniences.
Jesus dares to expect more from you who would follow Him.
You will soon discover—if you follow Him—
that the kind of peace He brings
is the very instigator of revolution,
that conflict and division
are necessary consequences of the Gospel.
And if you follow Him, you will discover, in some measure,
that the life you live and the stands you take
and the words you speak will sometimes engender division
and conflict—even among those you love the most—
which may result in suffering and persecution.
This is happening among His faithful followers
throughout the world today; it may happen to you.

To follow Christ means that you put your jobs, incomes,
interpersonal relationships, even your very lives
on the line in order that the kingdom of His Father
will be advanced throughout this world.

Luke 12:49-53

In a Conflict of Loyalties

So therefore, whoever of you does not renounce all that he has cannot be My disciple.—Luke 14:33

Jesus is, indeed, the Prince of peace,
 and you can follow Him
 only if you have His peace within yourselves—
 the peace of sins forgiven, the joy of being
 His redeemed and chosen servants and ministers,
 the security of life everlasting.
It is only when you are fortified with that divine peace
 that you will be able to confront
 the violence of this world with courage
 and the hostility of its citizens with love.
Christ's true followers are not those who retreat
 from the evils of this world to secure themselves
 until the kingdom is fulfilled and fully revealed,
 but those who are involved,
 even at the risk of life and goods,
 in the midst of the world's conflicts and revolutions
 and are there touching people with God's love and healing.

Christ's true followers must also regard His leadership
 and purposes as more important than everything
 else in their lives—even their very families.
Whereas you are to be faithful and responsible
 to those whom you love the most, your relationship
 to the kingdom of God enlightens and broadens your love

and extends your responsibilities
to all of God's creatures about you.
Every human being becomes your brother or sister.
You may, at times, be called to take some stand
or pursue some objective
that will wring the hearts of those you love
and cause division within your families.
In a conflict of loyalties you must obey God at all costs.
He has first call and claim upon your lives;
every other loyalty and relationship must be subjected
to your loyalty and relationship to God and His purposes.

What Jesus is saying is that if you cannot accept
and commit yourselves to this God as He has revealed Him,
it would be better that you return to the gods
that are more comfortable to worship
and make no demands on you.
Remember, however, that they are false gods
that can deliver nothing save darkness and despair.
Jesus invites you to follow Him even while He warns you
and suggests that you count the cost of such a decision—
then He urges you to come and experience the joy
of being the children and servants of the living God.

Mark 3:31-35; Luke 14:25-35

Following Boldly

And everyone who has left houses or brothers or sisters or
father or mother or children or lands, for My name's sake,
will receive a hundredfold, and inherit eternal life.
 Matthew 19:29

Jesus' first disciples literally left everything—
 their homes, families, jobs, property—
 to follow after Him.
He promised them that in the new world, the kingdom of God,
 they would receive a hundredfold more
 of everything they left behind.
This is His promise to you who follow Him.
Though previously expressed in human, comprehensible terms,
 He promises you that the regrets, sorrows, pains
 incurred by your decision to follow Him
 as the Savior and Lord of your lives
 will fade into insignificance
 in the joy of life and service
 in the kingdom of the Father.
He could not say any more than this
 for you are not capable of understanding it;
 there is no language in the world
 that can explain or describe it.
He seeks only to assure you that it is
 beyond anything you can possibly imagine.

Thus He knows that there is no risk
 in subjecting yourselves to the pain

of self-denial and cross-bearing on His behalf,
and He persists in urging you to make
what appears to you as a hazardous, risk-filled decision,
to trust Him, to boldly walk with Him
down the difficult paths of this world.
Those who invest everything—
their gifts of life, time, talents, worldly possessions—
in their own physical welfare or happiness
eventually lose it all.
The end result is emptiness and despair.
Those who invest their God-given lives and talents
in Jesus Christ and His purposes
will discover what true life is all about.
They will inherit life eternal.

If you are intent upon serving Christ, you must follow Him.
You must go where He goes, be where He is,
do what you know He would do.
Then, wherever you are, there He is also.
Inasmuch as you follow and serve Him
by being the loving servants of people around you,
you are honoring and serving your Father in heaven.

Matthew 19:27-30; John 12:24-26

Love One Another

You know that you can never measure up to God's standards
 by your efforts alone.
And this is true despite your sincerity
 or the various religious exercises you pursue.
It is for this reason that Christ came to you
 and died on the cross for your sins,
 setting you free from sin's bondage
 and canceling out guilt forever.
Thus, while you are yet sinners, you are saints,
 God's children, Christ's disciples.
The sure evidence of this relationship is God's love for you
 reflected and demonstrated in your love for one another.

Whereas the original commandments may not have taught you
 much about love, it was and is clearly revealed to you
 by Christ's life and ministry in this world.
Now you are ready to adopt a new commandment,
 a new ethic, one that was only dimly revealed
 and scarcely understood until Jesus came to this world.
It is the commandment to love one another.
There is no other way to indicate your sainthood—
 though many of you may rely
 on symbols and religious services
 to proclaim your identity as Christians.

Those symbols and religious exercises may mean something
 to you, but they hardly impress your peers around you.
If you are to follow Jesus, you must, by the grace of God
 and the work of His Spirit within you,
 learn what it means to love one another.
The standard or quality of such love is manifested
 in the way and manner in which He loves you.

It does not come naturally, this kind of love.
It is not easy, or even safe, to love others.
There are risks involved—
 the one who loves becomes vulnerable.
But the alternative is damnation—
 the lovelessness and loneliness of hell.
Love one another, you who follow Jesus,
 and you will thereby channel divine love to one another—
 and into the spent, lonely lives of others
 who cross your paths.

John 13:31-35

If You Really Believe

*Truly, truly, I say to you, he who believes in Me will also
do the works that I do; and greater works than these will
he do, because I go to the Father.—John 14:12*

If you really believe in Jesus Christ
 and commit yourselves to God through Him,

then you will embrace His purposes
and obey His commands
and emulate His life and activities.
He brought the kingdom of God into your midst;
you will be held responsible for living and serving
as citizens of the new kingdom
and through your witness and work
extending that kingdom in your community and world.
You will be privileged
to see in your time much greater things
than Jesus did when He was upon your world.
Jesus will be with you;
He will be working within and through you.
This was the reason He withdrew His physical presence
from the world—that He might return to you
through His Spirit that indwells you
and thereby carry out the purposes of His Father
on this planet.

God will bless you and guide you;
He will grant you the things you need to live
and witness joyfully and effectively.
You, however, are Christ's brothers and sisters
to whom He has delegated the responsibility
of communicating His love and healing to your peers,
of being God-incarnate in your generation.
He cannot reach them except through you.

It is an awesome responsibility; it is a joyful one as well.
Jesus promises you all that you need to accomplish
the task for which He has redeemed and chosen you.
You must pledge Him your faithfulness—your obedience—
even amidst the sufferings and frustrations
that will come your way.

Christ will be faithful to you; He will be with you;
 He will grant you His joy and peace;
 He will prepare a place for you
 in the eternal kingdom of His Father.
 "Let not your hearts be troubled, neither let them
 be afraid," He says to you.

John 14:12-17, 25-27

Reason for Celebration

> *Nevertheless do not rejoice in this, that the spirits are
> subject to you; but rejoice that your names are written in
> heaven.*—Luke 10:20

You remember and often reenact
 the last meal Jesus had with His disciples
 before He was betrayed and executed.
He revealed to them, thereby,
 a way in which they could be assured of His presence
 even if He could no longer physically be with them.
Ever since that very special time with His beloved followers,
 the breaking and eating of the bread
 and the drinking of the wine,
 revealing His body and blood and blessed by His Word,
 has been a tangible manifestation of His perpetual presence
 with those who love and follow Him.
This meal was originally with Christ's disciples.

It continues, in its reenactment,
 to be for His disciples alone.
This is His gift to you—to assure you
 of your forgiven and redeemed relationship to Him
 and His Father in heaven, to strengthen and encourage you
 in the great task before you,
 to convince you of His continued presence with you,
 to grant you joy and unity
 with your brothers and sisters who follow Him
 and who together with you make up Christ's body
 at work in the world today.
Come together often to worship God and to be touched
 by His Spirit in this very real and special way
 through this bread and wine.

Celebrate always God's grace and love
 that led to your salvation.
May your joy be centered not upon the visible
 successes and accomplishments that may result
 from your faithful obedience, but upon the assurance
 that you are truly God's beloved sons and daughters,
 are citizens of His kingdom,
 and the recipients of life everlasting.

It is His love that is revealed
 to seeking hearts through you,
 His comfort and healing that mends broken lives;
 by His redeeming grace are sin-ridden men and women
 restored to His will and orbit for their lives.
Love God and follow Jesus Christ;
 then the Father's kingdom will be advanced
 and His purposes accomplished through you.

Matthew 26:26-29; Luke 10:17-20

Scripture Index